illustration with TYPE

Martin Dawber

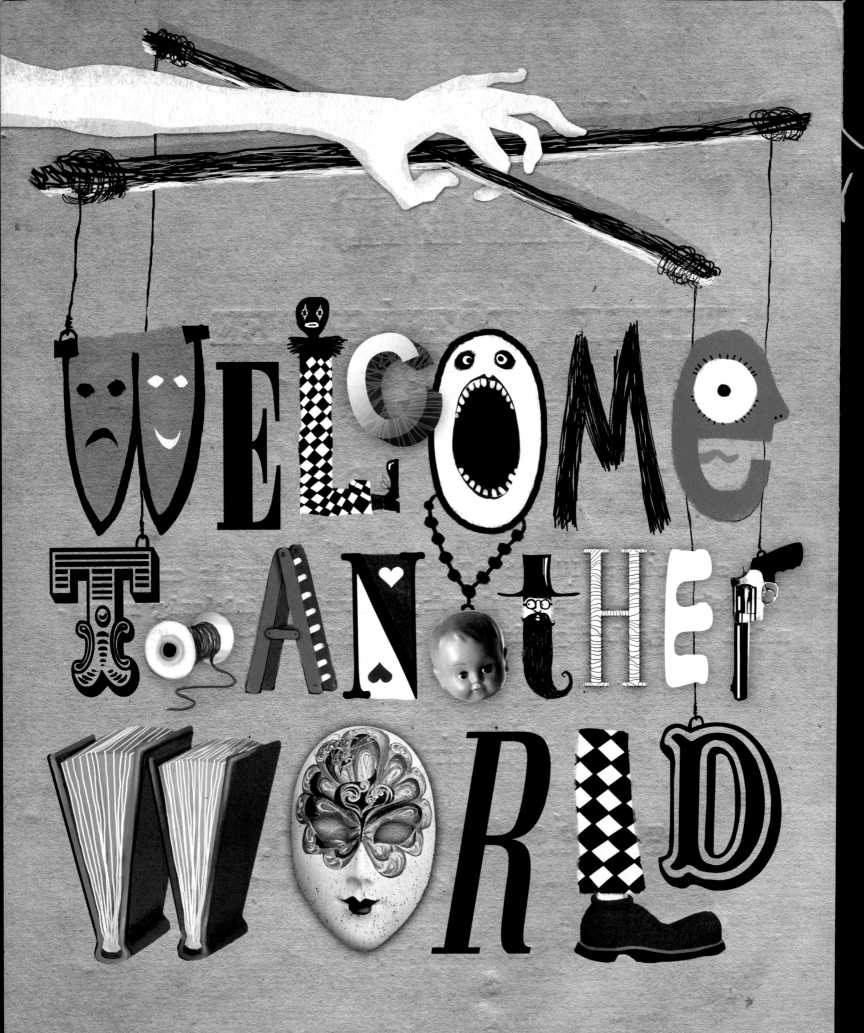

WELCOME TO ANOTHER WORLD

new illustration with TYPE

Martin Dawber

'What larks!'
Joe Gargery (*Great Expectations* by Charles Dickens)
This book is for my buddie and friend, Steve
– a man who knows a thing or two about text

First published in the United Kingdom in 2010 by
Batsford
10 Southcombe Street
London W14 0RA

An imprint of Anova Books Company Ltd

ISBN: 9781906388614

A CIP catalogue record for this book is available from the British Library.

15 14 13 12 11 10
10 9 8 7 6 5 4 3 2 1

Reproduction by Spectrum Colour Ltd, Ipswich
Printed by 1010 Printing International Ltd, China

This book can be ordered direct from the publisher at the website:
www.anovabooks.com, or try your local bookshop.

Distributed in the United States and Canada by Sterling Publishing Co.,
387 Park Avenue South, New York, NY 10016, USA

front cover:
illustration Helbotica
Fontbot by Jonathon Yule
date 2005
media/techniques Adobe
Illustrator

back cover:
illustration Illustrated
Banana by Sarah King
date 2007
media/techniques drawing
pen on fruit, photography,
Adobe Photoshop

previous page:
illustration Puppet Fair
by Mihail Mihaylov
date 2008
media/techniques Adobe
Photoshop

page 10:
illustration Good Bye Type 2
by Alex Camacho
date 2008
media/techniques Adobe
Photoshop

page 82:
illustration Kill That Gun Talk
(for W!LDWEEK) by Jeremy
Ryan Pettis
date 2008
media/techniques Adobe
Photoshop, Adobe Illustrator

page 134:
illustration EiE (Everything
is Energy) by Tony Ariawan
Kartiko, commission by
Thehizoku.com
date 2009
media/techniques Adobe
Photoshop

CONTENTS

FOREWORD

Typography today is alive and well. We need only to look back a few decades to see how far we have come. There was a time when typography consisted primarily of typefaces created by technicians and cast in metal. Next came typefaces projected onto film (phototypesetting) and, finally, digitized or computer-generated typefaces. Typography is an art that continues to grow and change.

Type can be expressive, entertaining, challenging, outrageous and, in the best examples, fine art. Some designers welcome change and the freedom to experiment, while others prefer a more traditional approach. Still others believe the old and the new can co-exist, which in the end will lead to a richer, more diverse world of typographic expression.

Hopefully, each new generation of graphic designers will continue to redefine the boundaries and conventions of their art. Some innovations will withstand the test of time, while others will simply represent passing fashions. All will add to the rich history of typography.

The wide range of personal styles represented here by these international artists and designers is visual proof of the array of global talent pushing against the contemporary type envelope. What is particularly striking is the rich diversity on show, especially in display faces. With digital technology it seems everyone can create their own typefaces, be it from found images, graffiti, paint blobs – you name it. If you can imagine it the computer can create it. Is this good? I don't know, but I certainly enjoy looking at the results.

James Craig
Typographer and Author
Adjunct Professor, The Cooper Union School of Art, New York City

left:
illustration True Type
by Karoly Kiralyfalvi
date 2007
media/techniques Adobe
Illustrator

'Type, the voice of the printed page, can be legible and dull,
or legible and fascinating, according to its design and treatment'.
Beatrice Warde (1900–1969), American typographer (*The Crystal Goblet*, 1956)

Text is everywhere. Everything from billboards and street signs, books and magazines, mobile phones and computer screens; they all spell out their messages using lettering and type. Once the valued craft of the typesetter, today it is tolerated chalked up on a restaurant slate, chiseled by hand on headstones or sprayed as graffiti on walls. It can inform you of where to go and also what is or is not permitted. It may be vulgar or deeply reverential. It can amuse or make you cry. It can tell the truth or offer a blatant lie. Type appears in all shapes and sizes, each with its own personality, ranging from the severe and classical through to the grotesque and weird. It can be a visually arresting headline of a newspaper or a delicate and understated signature on a private manuscript.

For today's savvy consumer there is as much fashion awareness in type and its treatment as the cut and colour of their personal wardrobe. Never satisfied with communicating just the meaning of the words, it is the way that the words visually perform that makes type so relevant in today's media ecology. During the digital revolution, the computer threw out all the rules and previous restrictions over type's limited availability no longer applied. It broke down the territorial rights between a designer and typographer with the lasting innovation that type and imagery have equal value. The latest technology has increased the opportunity for endless creative manipulation and experimentation. Everyone can now be their own typesetter as previously sought-after, unusual fonts are now a dime-a-dozen commodity available on every cover-mounted disc.

At its most fundamental, lettering provides an alternative and more permanent coding system than oral communication. Assorted abstract shapes are organized to articulate pictorially the sounds we make. But, just as with the tone of an actor's voice, the better designers have always been able to produce an additional expressive layer that lettering alone cannot accomplish. Harnessing their imagination and inventiveness they are able to draw out the creative potential of any alphabet and conjure lettering away from its information-only remit.

The union of art and typography has always enjoyed a rich and ever-expanding tradition that continues today with the transition from the printed hardcopy towards a virtual online environment. Visual communication, via simple pictographs, even predate the written word. These primitive symbols, painted onto Neolithic cave walls or carved into mammoth teeth, were the bedrock of the development of the first visual language. Simple pictographic 'writing' allowed not only for the representational (the sun, a tree or animal) but, by employing symbols, also conveyed a shorthand version of concepts (ideograms). Contemporary branding employs the same visual language. Carolyn Davidson's affirming 'swoosh' for Nike and Rob Janoff's bitten apple for Apple Inc. use the same formula and, by endorsing the point of sale, validate the status of the owner with a personal badge of recognition.

Even though the practice of impressing seals and signet rings preceded mechanical printing as a means of imparting a mark onto official documents, it was the cultivation of relief block printing (xylography) in China, followed by the invention of movable type during the Song Dynasty (960–1279AD), that launched the future of the format. The potential for printing with type came with the first mass-produced book, the *Gutenberg Bible* printed in Mainz in 1455AD. At over 1,200 pages, and using 42 lines of oil-based inked text per page, German goldsmith, Johann Gutenberg, revolutionized the production and availability of the printed page. It remained unchallenged for centuries as the accepted technology and updated mass communication with the same impact that the networked computer was later to instigate.

As the printing trade established itself so did the typeface industry. Fashions and design trends persisted to prompt changes in lettering styles and their application. Centuries later, the extravagant embellishments and ornamentation of the Victorian era gave way to the cleaner geometrics of Russian Constructivism and Italian Futurism, culminating in the stripped down functionalism of The Bauhaus following World War I. Only in existence for 14 years (1919–33), it set out to unify art, craft and industry – everything from typography to tapestry. Current graphic design can be attributed to the Modernist teachings of Laszlo Moholy-Nagy and Herbert Bayer, where text demanded as much respect and positioning as an image. These pioneers paved the way for the orderly International Style adopted in 1950s corporate advertising by emphasizing san serif fonts grounded in a structured grid that evidenced lots of white space.

During the 1980s software packages (Quark Express, Adobe Photoshop and many others) replaced the reliance upon manual layout and became the designer's preferred creative tool. The advances in technology directed interest away from the reality of the printed page towards the virtual environment of the computer screen. Initially hampered by the restrictions that HMTL placed over the choices of font, colour and style, the arrival of cascading style sheets (CSS), has allowed the flexibility and control that designers working via the web demand. Two of the most influential designers of the computer age are Neville Brody (UK) and David Carson (America). In a spirit of extreme experimentation and deconstruction they have re-set the parameters for all future representation by pushing the conventions of type, its design and purpose to the limit. The prime consideration of communication and legibility were contested as type became a free agent. Unshackled from the typesetter's line it was able to roam the page at will. Rules of engagement within typography and design became distorted and disregarded and, for some, their experiments seemed to be heralding the end of printed typography.

However, in a society that gleans most of its information from a screen-based culture, communication has long outgrown the rules of conventional expression and the best of today's typography equally demands to be seen as well as read. The designers featured here are all testimony that type continues to evolve and strong evidence (if any were needed) of the creativity and imagination that today's exponents are bringing to letterforms in all its contemporary guises.

EUROPE

ALEX CAMACHO

Birthplace: Barcelona, Spain. *Education:* Escola Superior de Disseny Elisava in Barcelona. *Inspiration:* Alex Trochut, Experimental Jetset, Marian Bantjes, Stefan Sagmeister, Underware.

Creativity has always been a driving force in my life. Since childhood, I have loved expressing myself through drawing and there was never any doubt in my mind that I wanted to go to art school. As a child I enjoyed drawing and being creative as a game but now creativity is both my passion and my profession.

I started to be interested in graphic design because of its communicative power. I was accepted onto the graphic design program at the Escola Superior de Disseny Elisava, which opened my mind and solidified my life-long passion for the aesthetic. After my studies I travelled across England and America before returning to Barcelona, where I now work for a communication studio. In order to be able to design more freely, I have also started to work on a freelance basis.

My obsession with lettering has grown step by step. I have created graffiti from a young age, but as a student I was more interested in other aspects of graphic design. After my degree I started to work more with text and became increasingly interested in letters, to the point when I realized that I wanted to dedicate all my time to this wonderful area. I think of typeface designers as craftsmen who gradually polish the alphabets used everyday. I consider typography to be an art – some alphabets deserve to be in museums, they are created so perfectly.

I don't have a preferred method of working and like to vary my techniques – they can be traditional or digital depending on the project. Every project is different and I approach each one ready to adapt to specific needs. I try to be innovative. Living in the era of the internet, it is very difficult not to be influenced by all the images available to us. I like to attempt new and different things and, if they already exist, make them better. Although the internet is a non-stop creative gallery, it is my hometown of Barcelona that is the biggest influence on my work. Barcelona is rich in all cultural aspects – whether art, music or architecture – which all have a strong personal influence. I take inspiration from all around me – each small detail suggests ideas for a new design.

I start by thinking about what it is I want to convey and how best to communicate the idea. I then create as many sketches as I need to find the correct shapes. I always begin the final artwork with a clear idea of its destination and function in mind because this can restrict options over size, colour and typography.

When I finish a project and am happy with the results, it compensates for all the hard work. From my point of view, when a person follows what he or she enjoys, sooner or later they will become a good designer because of the interest and passion they put into their work.

right:
illustration 1965, Op Art
date 2008
media/techniques Adobe Illustrator, handmade lettering

above:
illustration Tempest Summer
date 2007
media/techniques Macromedia
Freehand

right:
illustration Modular Type
date 2009
media/techniques Adobe
Illustrator

leftt:
illustration Roima Letters:
'Altabet de Papers'
date 2008
media/techniques paper

right:
illustration Good Bye Type
date 2008
media/techniques Adobe
Photoshop

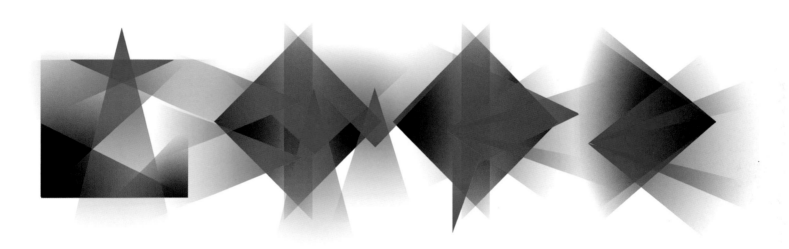

right:
illustration Creativity+Commerce
date 2008
media/techniques Adobe Illustrator

Birthplace: I grew up in a *moshav* (a cooperative Israeli settlement) called Bitan Aharon, near Netanya, Israel. *Education:* Shenkar Institution, Ramat-Gan, Israel. *Inspiration:* Sofia Coppola, Pedro Almodóvar, The Chemical Brothers, Lionel Messi, Stanley Kubrick.

Since I was young I was always involved in music – playing in bands and later on producing electronic music. My inspiration continues to originate from music and I see the transition from music production to design as natural progression. Just as I want things to sound good, I also like them to look good. Electro music has had a strong influence on my work. The French record label Ed Banger is always an inspiration – not just musically but also visually. In particular the recording artists Justice, Mr. Oizo and Teenage Bad Girl are influential to my work. I am continually impressed by the Israeli typography artist Oded Ezer who exhibits his work under the project title of Biotypography. I also see the posters of a Dutch artist known as Parra as pure breathtaking treasures.

It is difficult for me to explain my passion for typography. I love the shapes and aesthetics the words create and enjoy investigating the internal spaces within the letters. I like to push the boundaries of a letter, to see how much I can play with it without disturbing its functionality – so that it can look good and be interesting, but is still be readable. When form follows function, then the magic really comes alive. I am always amazed by the sensitivity and the concentration that designing typeface requires, whether it appears as a poster, a font or in any other form.

There are many talented Israeli designers, but still not enough typographic qualities and evaluation in Israel. At the beginning of my career I attempted to create new artwork in English but quickly transferred to Hebrew, my mother tongue. The Hebrew alphabet is difficult to work with as it is built upon a sequence of square shapes. It is a great challenge to renew this ancient language with fresh and modern usage, testing the flexibility of the letters to their limit and adjusting their natural shapes.

I start my original sketches using paper and pen before moving across to computer software (Adobe Illustrator). I treat the process like a sculpture – I build a raw shape and go through a process of adding and deducting until I get it as close as possible to smooth and interesting curves. In theory I could keep improving my work forever – there are always ways to refine a finished piece. I like to get to the point when my work feels whole, but not necessarily perfect – when it truly transmits the sense or the idea that I want it to express. Most importantly, I want my work to look like it was completed effortlessly.

Typography will continue to develop in the future. Print design and classic typefaces will always be around. Text remains an essential tool of communication. Today's technologies are just another platform for the expression of art.

YAIR
COHEN

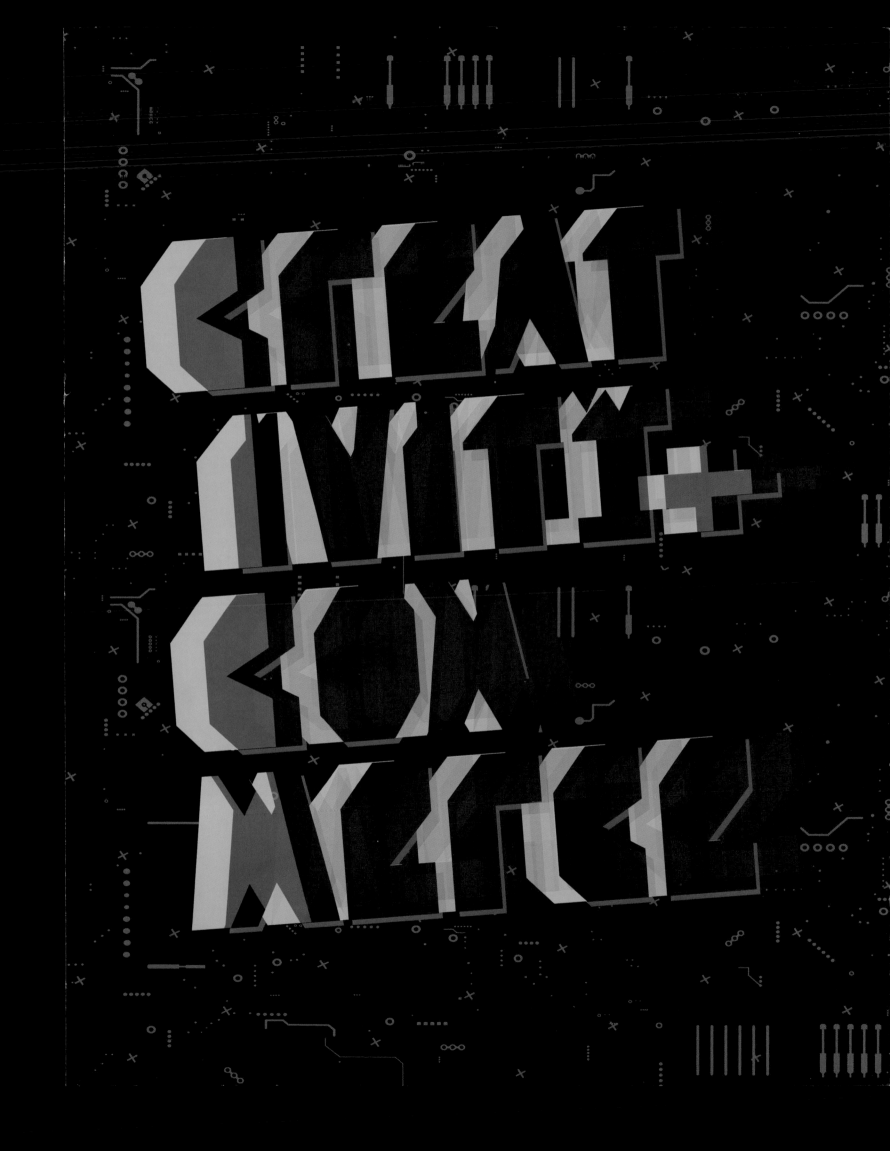

Birthplace: Istanbul, Turkey. *Education*: Bilgi University, Istanbul. *Inspiration:* Niklaus Troxler, Massimo Vignelli, Marian Bantjes, Jonathan Barnbrook, Peter Bilak, Tobias Frere-Jones.

The most important part of designing type is the concepts and ideas behind the letters. Typography can stimulate different feelings, thoughts and memories and I believe that letters have very human characteristics in the way that they socialize and interact with each other.

I decided to study electronic engineering at university but soon realized that it was not for me. I needed to exploit my creativity through art and design, just as I had done in childhood. I was introduced to the world of typography during design studies, where I fell under the influence of the type 'masters' who invoked my passion for type design and lettering.

Fascinated by the geometry and proportions that are found in nature and architecture, I prefer everything to be symmetric and aesthetic. I take my inspiration from all around me – urban sounds I hear while eating döner at a buffet in Taksim, the view of Istanbul from the Princes' Islands, or the sharp, geometric shadows of a building. I love both Modernism and Minimalism, but am equally attracted to Fluxus or any kind of performance art and have a passion for expressionism in any field.

Design is based on fundamental principles (Gestalt or Fibonacci numbers) that have to be observed, but I believe that rules are there to be broken. I like to be rebellious and doing what is not allowed. I am aware of current trends but it is never my intention to imitate. I filter and digest the information and then find my own way to interpret it.

I prepare a set of ideas and think about the concept and realization process, always trying to involve a variety of production skills and tools. I prefer to start by hand and scan the material rather than spend hours in front of the computer screen. I use photography and try to use the camera to adjust my perception of objects and scenes. I particularly like to interact with nature, the environment and to observe human behaviour. Although I consider socializing to be very important to a designer, I like some parts of my day to be silent and even isolated. I like listening to my own thoughts, which is maybe why I usually work late into the night.

Although large companies and corporations are involved in using typography to develop brands and logos, and can easily compete in terms of technology, I believe that it is the design strategies and ambience that identifies the work as either the best or the worst in its field.

There will always be a demand for type. Every day an old style will reappear and become popular again and there seems to be no limit to the number of ways that a design style can be reinvented. I believe the new technologies and communication media will aid this process and dictate the future of type.

right:
illustration Re:petition Poster
date 2007
media/techniques Freehand MXa

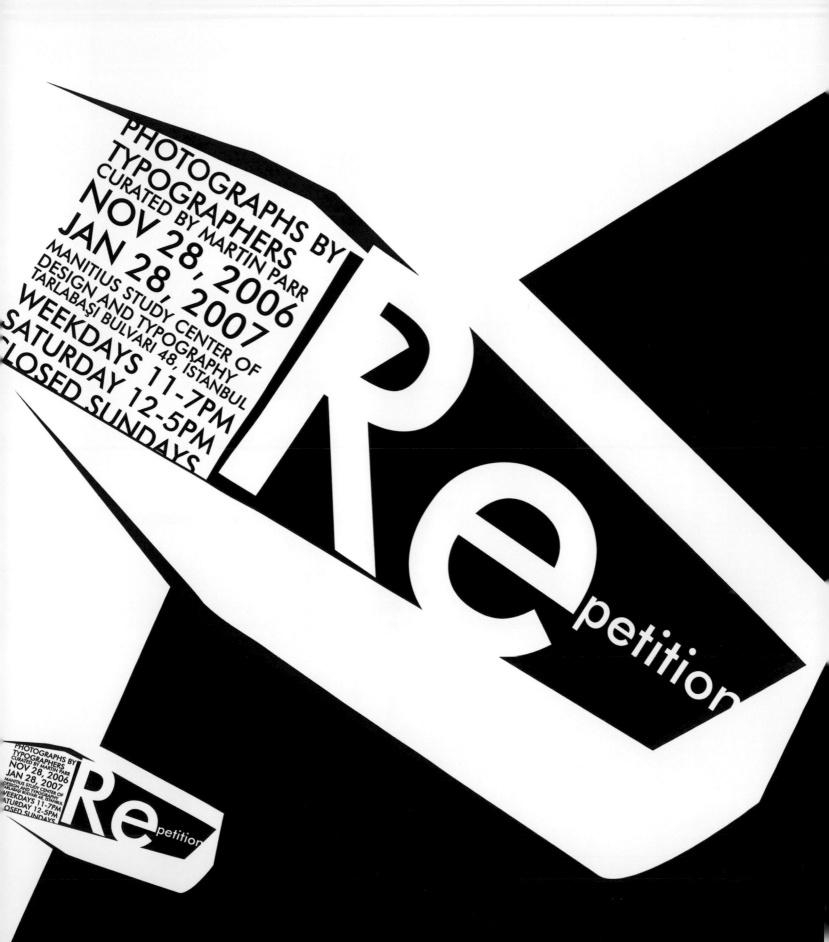

PHOTOGRAPHS BY
TYPOGRAPHERS
CURATED BY MARTIN PARR
NOV 28, 2006
JAN 28, 2007
MANITIUS STUDY CENTER OF
DESIGN AND TYPOGRAPHY
TARLABAŞI BULVARI 48, İSTANBUL
WEEKDAYS 11-7PM
SATURDAY 12-5PM
CLOSED SUNDAYS

Repetition

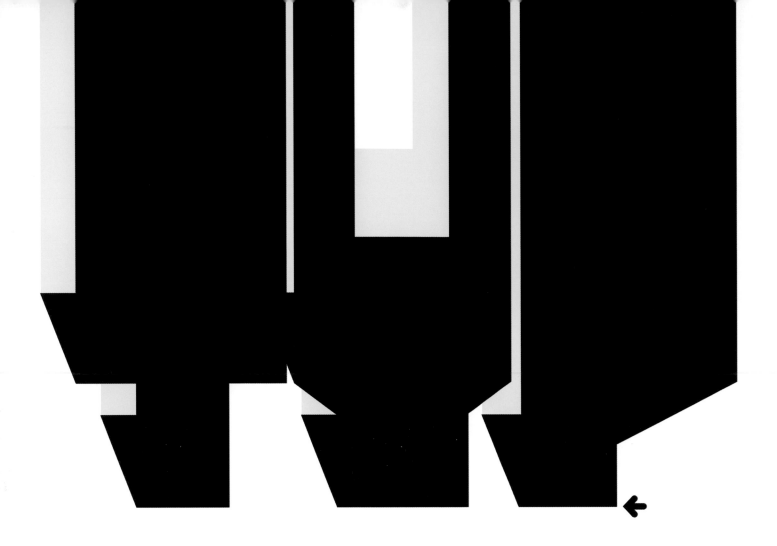

above:
illustration TYP Logo
date 2008
media/techniques Freehand MXa

right:
illustration OCR (Optical Character
Recognition)
date 2008
media/techniques Freehand MXa

opti-
cal
char-
acter

 recog-
nition

right:
illustration Typobox Ying
Yang Poster
date 2008
media/techniques Freehand MXa

below:
illustration Postal Love Postcard
date 2009
media/techniques Adobe Illustrator

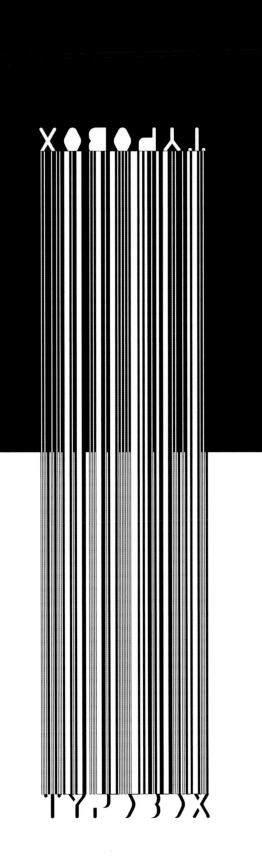

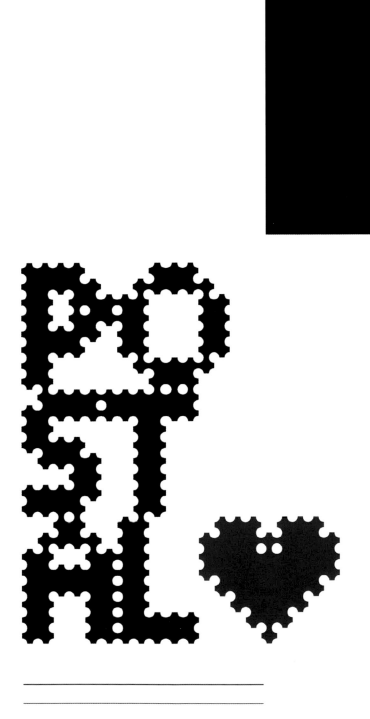

Birthplace: Csanádapáca, Hungary. *Education:* Eötvös Loránd University (ELTE), Budapest and Krea Art School, Budapest. *Inspiration:* Martin Majoor, Wassily Kandinsky, James Joyce, János Pilinszky, Japanese Art.

Art has always been a part of my life from the very beginning and I have drawn and painted from a young age. Type and letterforms are a more recent obsession but they are currently the most important to me. I simply love all aspects of typography.

Beyond the mere lines of text there are almost endless possibilities that can be shaped and fine-tuned if you are lucky enough to have skilled hands and steady eyes. Once the typographic fever begins, one becomes highly sensitive to detail – shapes, rhythm, contrast, regularities and exceptions. A designer can achieve almost anything with typographical elements and the learning possibilities never end. A willingness to learn is a key factor in any designer's work. Recently I have begun to experiment with typeface design using both traditional and digital techniques. It is important to me that there are no restrictions on the tools available when creating.

I can take inspiration from almost anything – movies, magazines or a well-kerned title for example – but also a shape, colour or scent, a book, a statue or even having a good chat with other creative people can be equally inspiring. The main influences on my work at the moment are abstract and modern artists from the 20th century, as well as contemporary designers, artists, and type designers such as Kandinsky, Martin Majoor, and János Pilinszky. I also take inspiration from ancient Japanese art.

My preferred method of working is usually via constant doodling. I sketch a lot, both day and night, with anything and on anything. I usually store every piece of paper or else carry my doodles, no matter how small, since at any moment they might inspire or develop into a new design or piece of art. I like to work fast and keep experimenting until the moment that I feel that the piece is ready and I could not improve it any further. For me it will always be the process of creation that is the most important consideration when designing. I try not to put too much emphasis on the finished piece. I would always recommend any art or design student draw as much as possible and think with their hand! Experiment, collect, arrange and re-arrange everything. Listen to everyone's opinions but listen mainly to yourself in order to fulfill your creative potential.

I believe that the future is bright for type and typography. It is an ever-changing art form. Just as it was a vital part of design in the past, it is equally important in the present. I suppose that eventually type will return to its roots as image – the boundaries between the two will become indistinguishable and vanish as type and image grow closer to each other once again.

BÉLA FRANK (AKA FABERGRAPH)

and

s driv

crazy there

body

to love

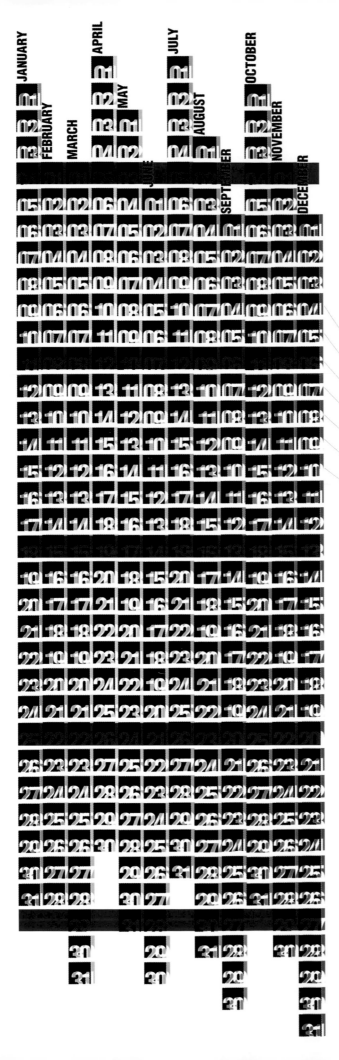

left:
illustration Helvetica Calendar
date 2009
media/techniques Adobe Illustrator

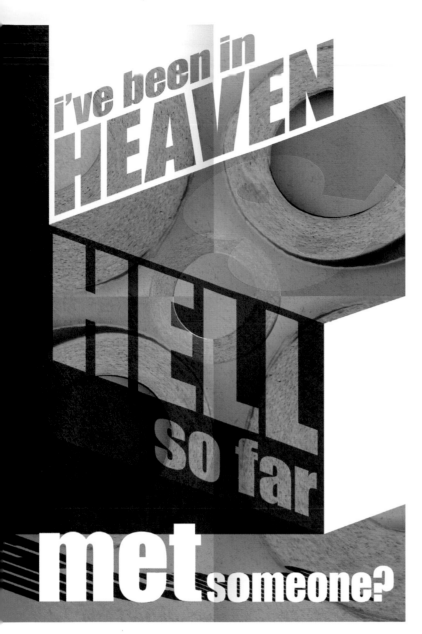

above left:
illustration I've Been In Heaven and Hell
date 2008
media/techniques Adobe Photoshop

above right:
illustration Pure, Version 1
date 2009
media/techniques Adobe Photoshop, Adobe Illustrator, Cinema 4D

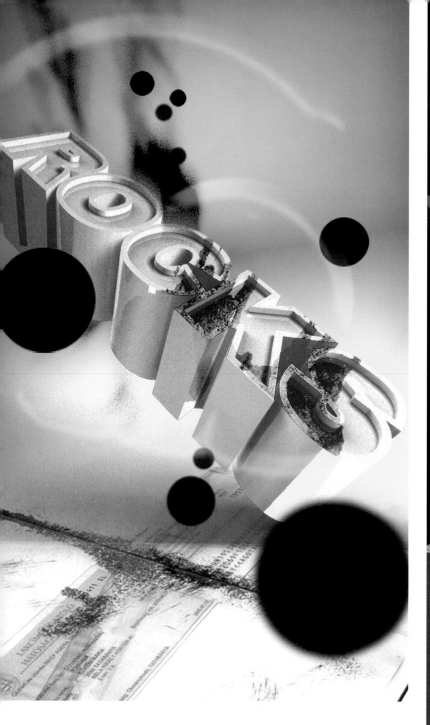

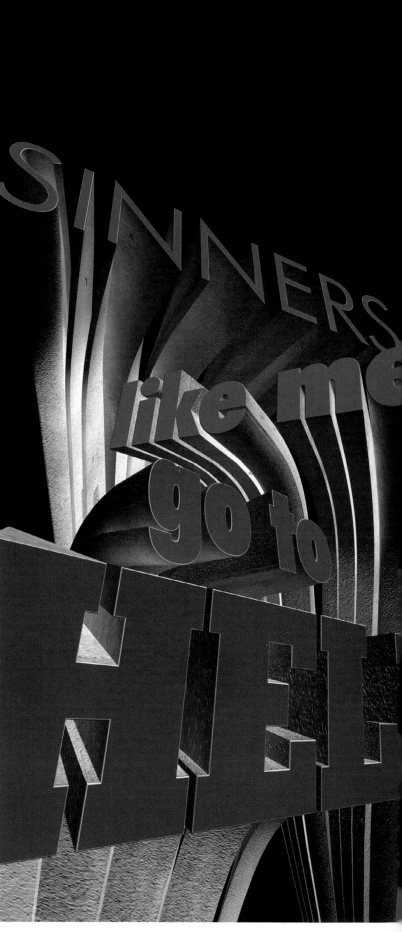

above:
illustration Rocks
date 2009
media/techniques Adobe
Photoshop, Cinema 4D

right:
illustration Sinners Like Me
date 2009
media/techniques Cinema 4D

right:
illustration Feuer
date 2009
media/techniques Adobe
Photoshop

below:
illustration I Like These Colours
date 2009
media/techniques Adobe
Photoshop, Cinema 4D

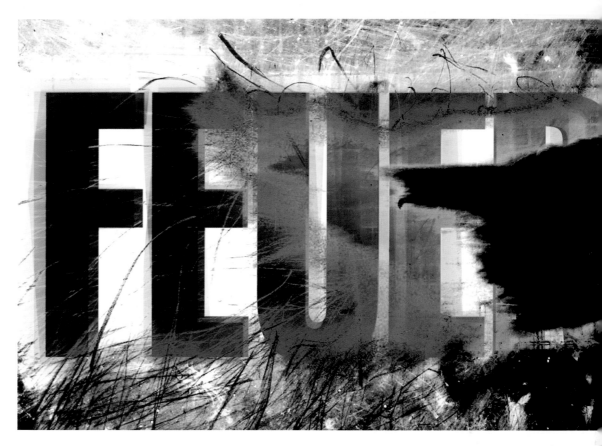

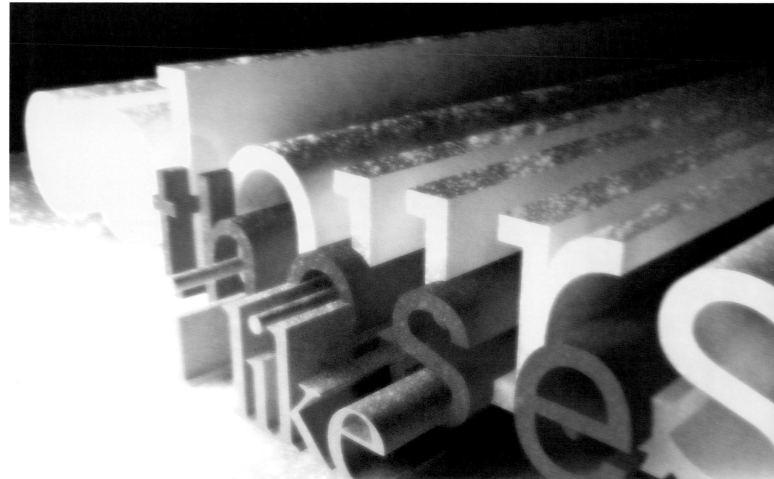

JAUME OSMAN GRANDA

Birthplace: Vilanova i la Geltrú, Barcelona, Spain. *Education*: UPC University, Barcelona. *Inspiration*: Alex Trochut, Albert Pla, Salvador Dalí, Pepe Rubianes, Si Scott.

After taking multimedia studies at UPC University in Barcelona I worked for a while designing websites and related media. Although I still design websites from time to time, I am now far more involved with design and illustration, which I find much more appealing.

I'm not really sure if I've got any particular personal style because I like to keep trying out new things, just as I did when I first started. I am always experimenting with different styles, new techniques – anything that keeps me away from routine. I get tired of churning out the same things.

When I start work on a project, my initial approach is to treat it as an artwork. It is difficult to maintain this approach though – when a client asks to change things, it is easy to lose the artistic spirit that the piece started out with.

Although I work a lot with vectors using a graphic tablet, I also like to incorporate my own scanned textures, such as fabrics and stains, into the work. I love freehand illustration but it doesn't really suit my style. I try to apply illustration techniques to typography because it come much easier to me. I really love trying out new things and experimenting. I usually work with Adobe Illustrator and Photoshop, but lately I've been trying out programs for animation and 3D, such as After Effects.

Although I know how effective preparatory sketches on paper can be, I prefer to start work directly on the computer with no idea of what the final piece will look like. After a while I will start to generate an idea either on the computer or on paper if I consider it necessary. One thing that I've learned is to allow time for my work to develop. Sometimes I get fed up with it and on these occasions I prefer to leave it for a while and return to it after a few days.

I don't think that type has changed that much over time. It is the way in which typography is created and executed that continues to evolve. I didn't study the history of design at university, so I consider myself a bit illiterate on the subject. I respect contemporary designers more than the old masters. It is fashionable to say that you take your inspiration from historical designers but I prefer to keep my eye on the present day. What I see on the internet or catch on the television allows me access to new ideas and to new designers – it doesn't really matter to me if they are well-known or not.

When you are doing something that you really enjoy, learning comes easily. The trick is having a clear idea of what suits you so that you don't waste a lot of time learning skills you don't actually like!

right:
illustration Belio Magazine
date 2009
media/techniques Adobe Illustrator

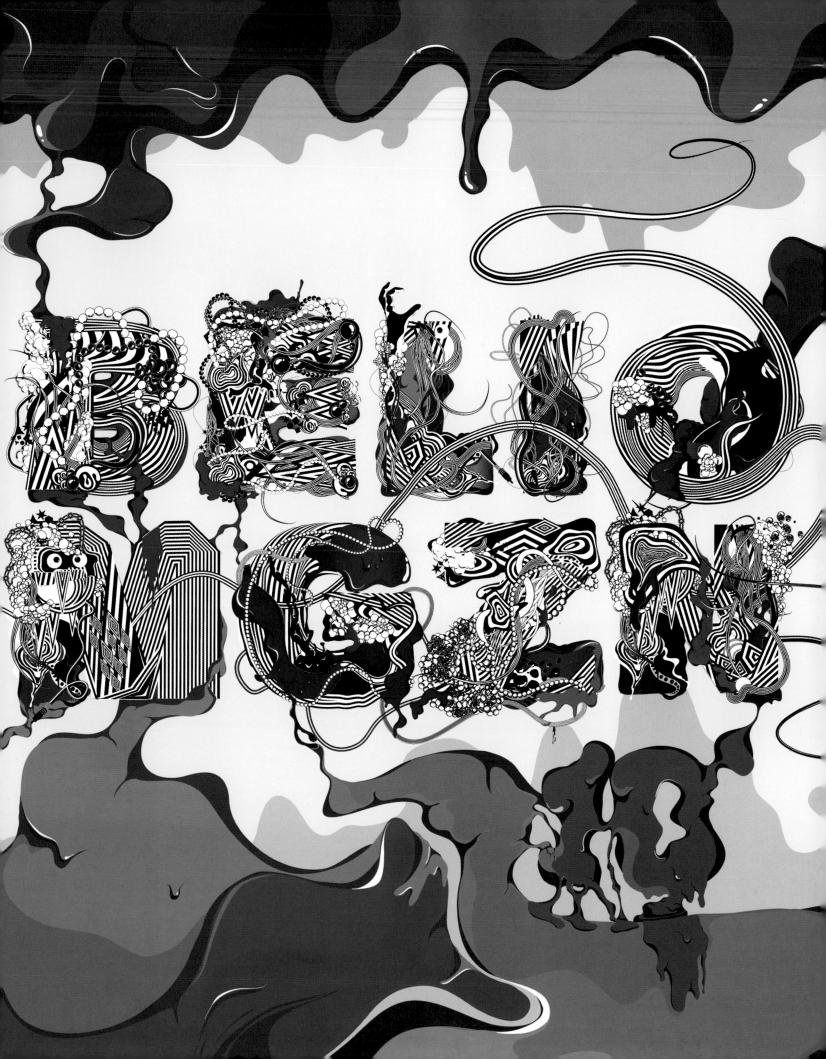

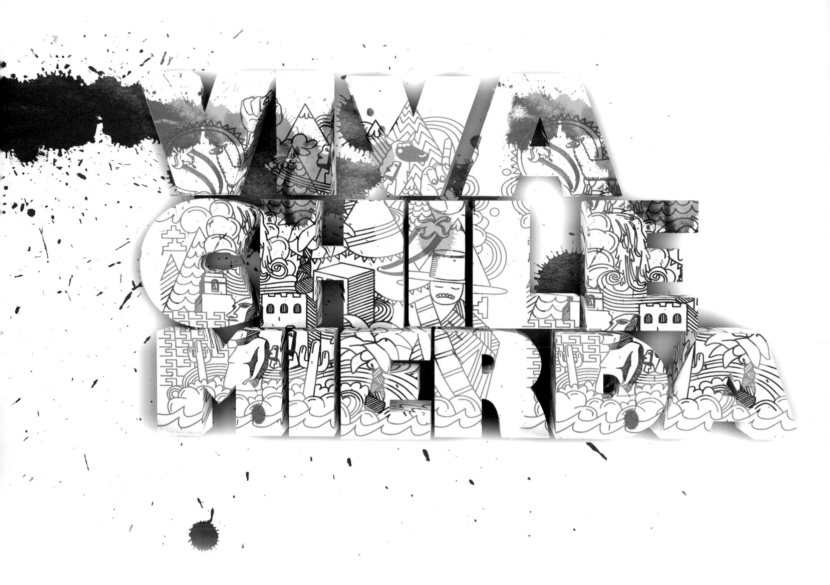

above:
illustration Viva Chile Mierda
date 2008
media/techniques pencil,
Cinema 4D

right:
illustration Gothalans Northern
Tribes
date 2007
media/techniques pencil,
Adobe Illustrator

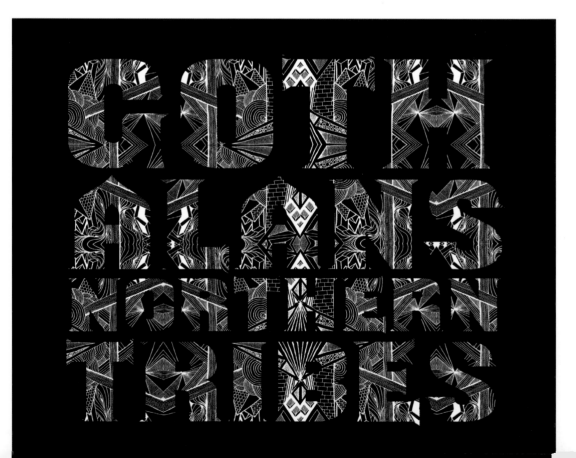

right:
illustration Serial Lover
date 2008
media/techniques Adobe Illustrator

below:
illustration David Tort
date 2007
media/techniques Adobe Illustrator

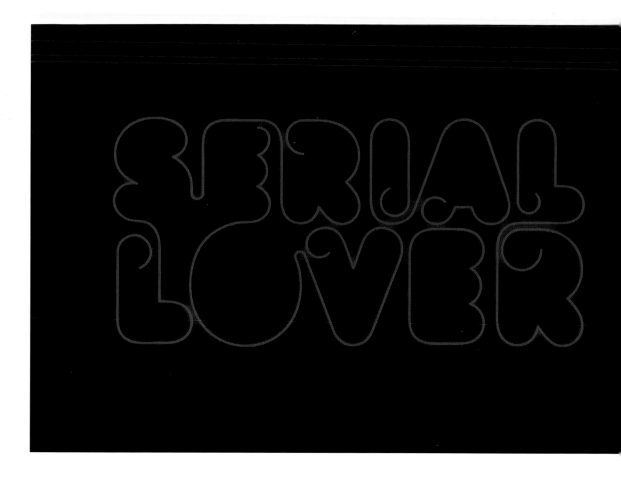

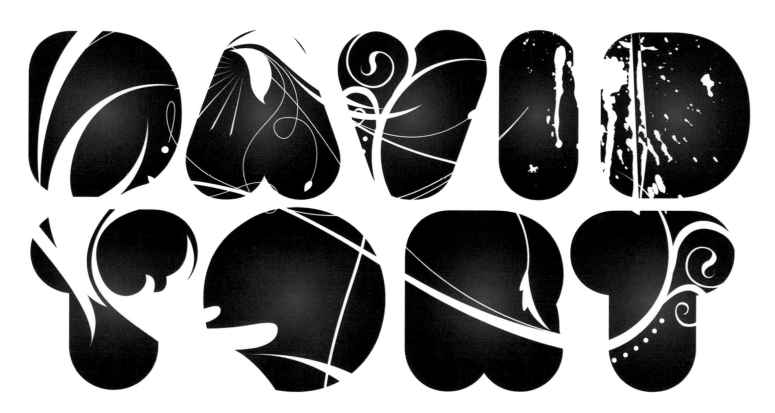

right:
illustration Critically Endangered
date 2008
media/techniques drawing pen,
Adobe Photoshop

Birthplace: London, UK. *Education:* University of Brighton, England. *Inspiration:* Peter King, David Attenborough, Jacques Cousteau, Wes Anderson, The Cohen Brothers, John Vernon Lord, Eric Carle.

As soon as I could pick up a pen as a child I knew that I was destined to be an illustrator. One of my first childhood memories I have is of making some illustrated short stories when I was five years old. After graduating with a degree in graphic design I went to New York to do a four-month internship with Mike Perry. Mike is a very inspiring person – he manages to create seemingly endless amounts of great work. On my return to London I began working as a freelance illustrator. Sometime in the future, I would love to get a studio with a group of like-minded friends.

I started using a lot of hand-drawn type in my final year at university. It wasn't fully thought out, it just seemed to work and was incredibly satisfying. After graduating I realized that there was a huge amount of varied work involving illustrated type. I have been incredibly lucky to be able to continue working at what I like to do.

If I had to describe my own style it would be 'illustrated organic typography'.

Ideas for my work really depend upon the needs of each project. Every one can take shape in a slightly different way. If something doesn't immediately come to mind I'll look though books, photographs, stories, films, animation and so on – almost anything that might be a source of inspiration.

I always begin with pen and paper, then scan and edit my illustrations on the computer using Adobe Photoshop. I regard my work as both an art and a craft. Although I prefer to work with pen on paper, a mixture of traditional methods with digital editing can work wonders with the final piece.

It is very important to give the client something they want – although it doesn't have to be exactly what they say they want to begin with. I find it is very important to work closely with clients and be able to develop the idea with them.

My advice to young creatives is not to get too disheartened if things don't happen straight away. Get a good website and portfolio together and just keep creating.

SARAH
KING

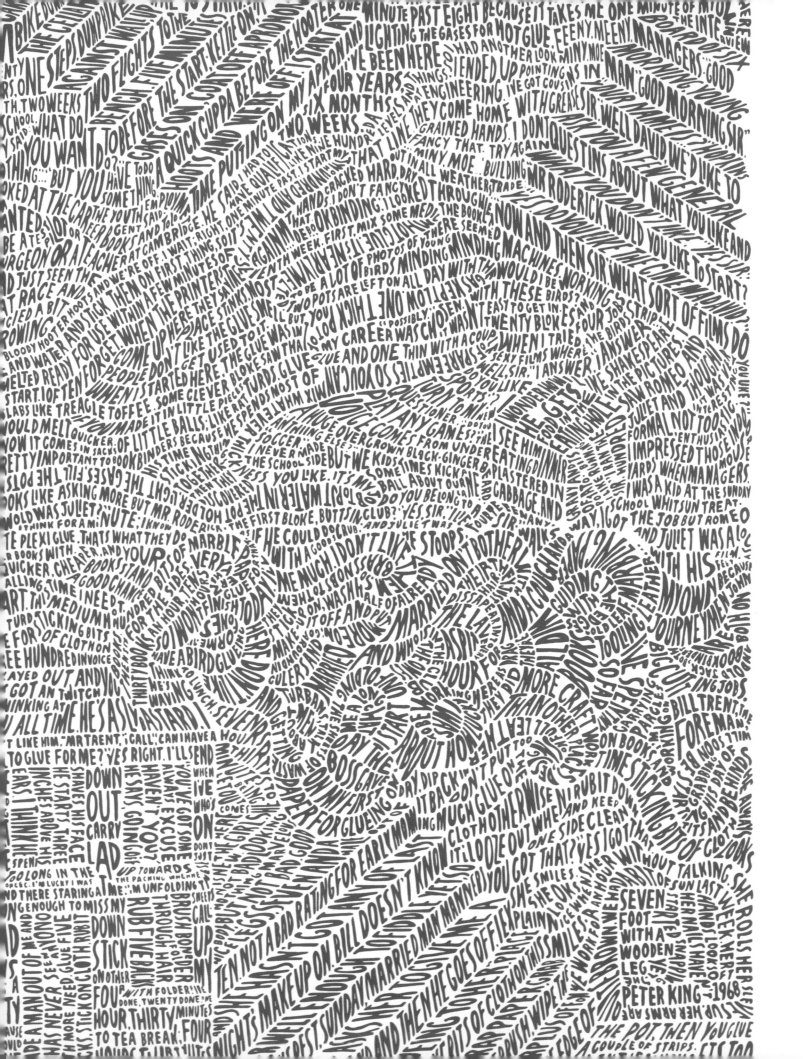

PETER KING – 1968

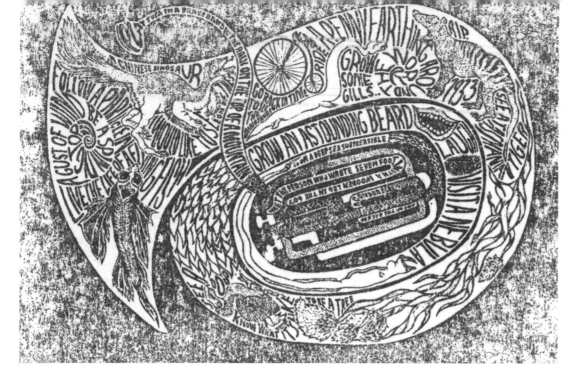

opposite:
illustration Seven Foot with
a Wooden Leg
date 2008
media/techniques drawing pen,
Adobe Photoshop, screen print

left:
illustration If I Could
date 2008
media/techniques drawing pen,
Adobe Photoshop, screen print

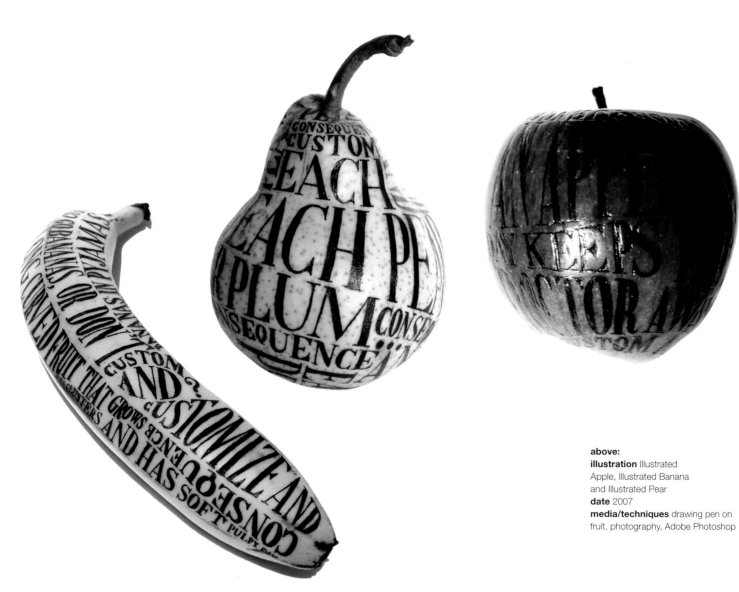

above:
illustration Illustrated
Apple, Illustrated Banana
and Illustrated Pear
date 2007
media/techniques drawing pen on
fruit, photography, Adobe Photoshop

KAROLY KIRALYFALVI

Birthplace: Budapest, Hungary. *Education:* Ecole d'Art Maryse Eloy, Budapest. *Inspiration:* Alex Trochut, Sanna Annukka, Parra, Büro Destruct, Grotesk.

Growing up in Budapest, I was always interested in the visual arts. One of the greatest influences on me was my father, who was a painter, a poet and a sculptor. He passed on all the advice that he had about craftsmanship. I spent most of my younger days as a little boy who loved to draw and build Lego and most of what I learned was through self-education. Pencils and markers were always my tools, until my father brought home our first computer. That was when my focus changed, and illustration has been my passion ever since. I found my place in the contemporary graphic design scene by spending hours in front of the computer on the internet. 90 per cent of my current work is based in desktop publishing, creating flyers, posters, brochures, books and magazines, although I prefer to create logos and typefaces.

I think one of the most important qualities of a graphic designer is to stay fresh by working on different themes for a mixed range of clients. I worked with several teams, agencies and studios, but the switch over to freelancing was my best decision. As a freelancer there is much more freedom but it can be difficult to control your everyday schedule. I believe it's the perfect way to work and I won't switch back to working in the corporate world.

In my own work I try to represent all of my experiences and influences. The street, and the whole concept of 'urban life', is one of the most important inspirations for me. To live in a big city – full of people, shops, buildings, panorama, and advertisements – offers a daily dose of new ideas. Almost anything is an inspiration, even if you don't realise it at the time. I'm also a daily visitor of the main design portals on the web.

From the brief to the finished work, the whole design process is dependent upon the clients. I ask the client what they want and make some sketches based on that. Then we continue with one of these designs until the final graphics are completed. I don't usually do pencil sketches, but start to collect some images from the internet and vectors from my hard disks. During the preparation process, I'm trying to think hard about the different layouts and possibilities, what to do and how to do it. With Adobe Photoshop and Illustrator I can achieve most of my ideas and concepts. The synergy between Illustrator files and Photoshop is particularly helpful when working on a design as I often have to use both for one piece of work.

I think that the current design scene is really progressive. The main thing is to be up-to-date all the time. It's quite significant to see other people's work, to browse stuff from the past, see artworks by artists that you appreciate, and so on, but it is also important to see the bad examples and the trends that go wrong.

right:
illustration Match Me if You Can
date 2008
media/techniques Adobe Illustrator

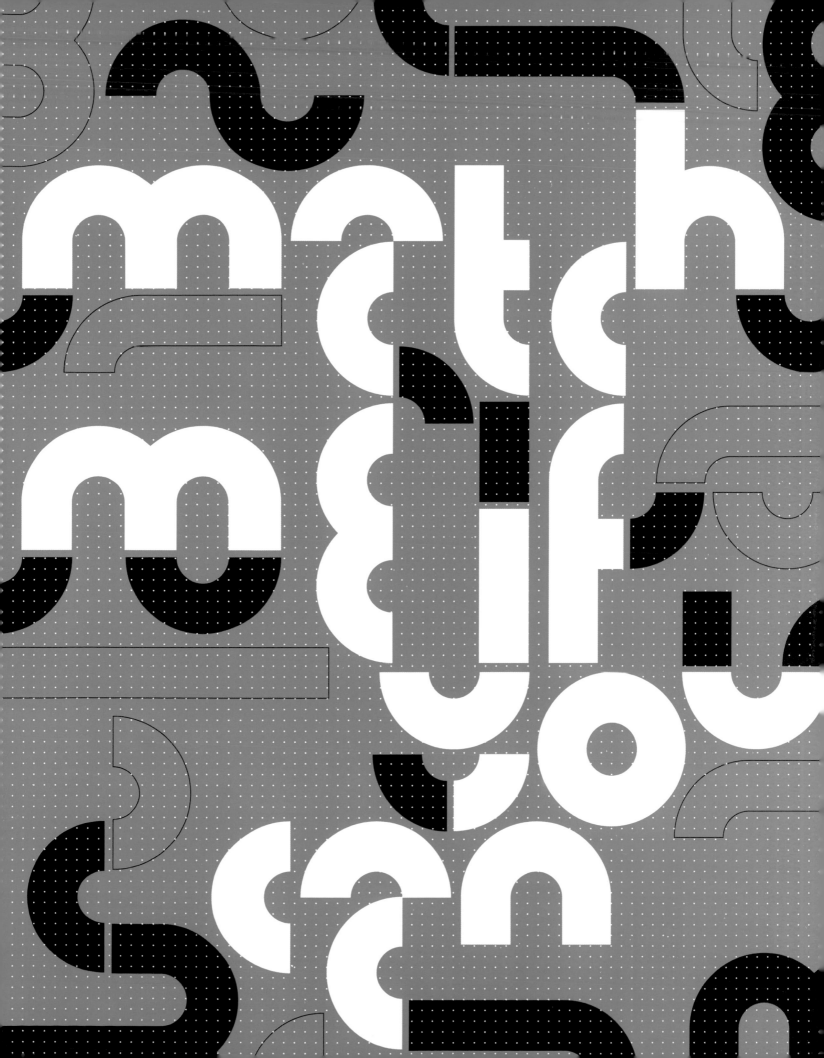

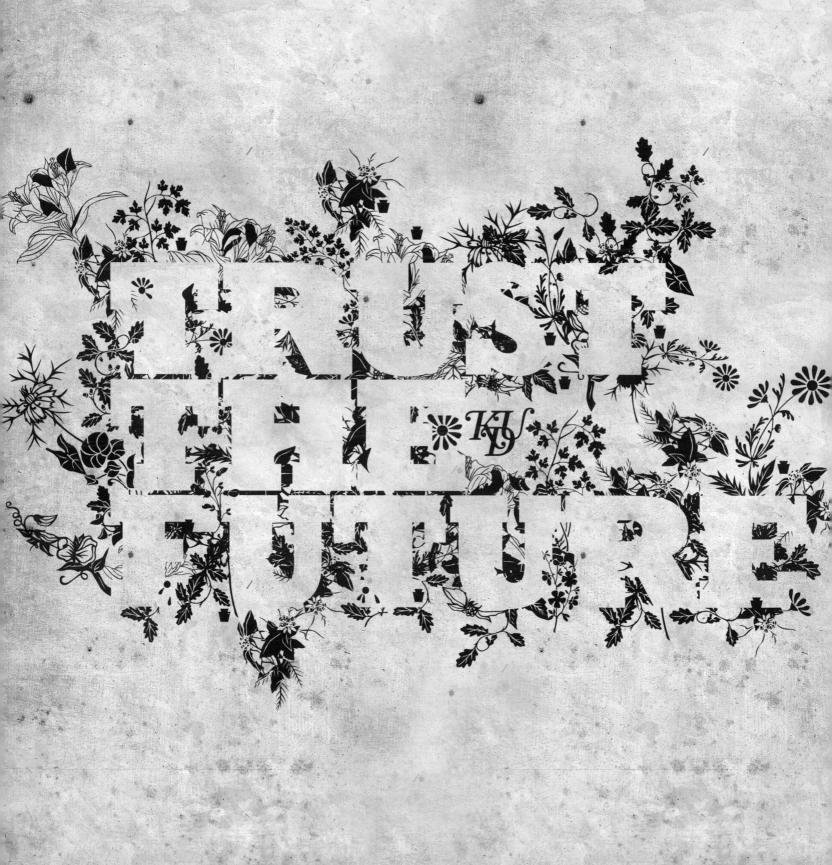

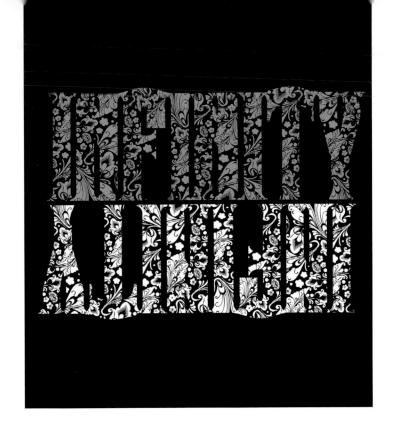

opposite:
illustration Trust the Future 2
date 2008
media/techniques Adobe Illustrator

left:
illustration Infinity
date 2008
media/techniques Adobe Illustrator

below left:
illustration Finders Keepers
date 2008
media/techniques Adobe Illustrator

below right:
illustration Coming Strong
Coming Correct
date 2007
media/techniques Adobe Illustrator

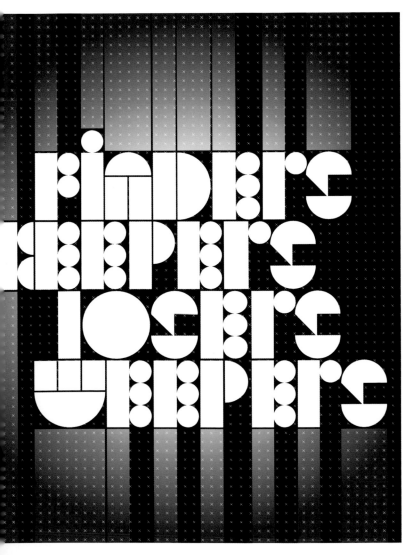

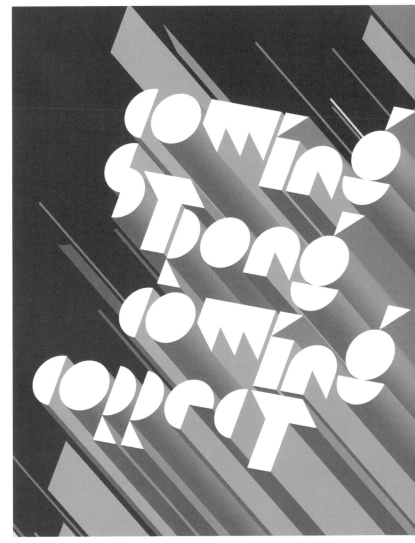

right:
illustration Typo
date 2008
media/techniques Adobe
Photoshop

Birthplace: Sofia, Bulgaria. *Education:* School of Arts and Crafts, Sofia and National Academy of Arts, Sofia, Bulgaria. *Inspiration:* Roisin Murphy, Jenna Jameson, Christina Aguilera, Scarlett Johansson, Queen Elizabeth II.

I come from an artistic family. My father is a well-known caricaturist and illustrator, my mother is a pianist and my sister is a musician. Growing up, there was no question that I would become an artist – it seemed quite a natural progression. The only question was about what kind of artist I would be. After graduating from the School of Arts and Crafts in Sofia, I studied book design and illustration at the National Academy of Arts. I now work as a graphic designer for an advertising agency in Sofia, as well as working freelance.

Type and text are fundamental to graphic design. The aesthetics of type are part of everyday human life; using type to express an idea will always be intrinsic to how we live. You can use type semantically or you can explore the shape of the letters as a graphic form. In my own work I see a relationship between letterforms and proportions of the human body. I believe that you must know the rules to break them. The method of application will always depend upon the initial concept and will also be an important part of the final work.

I know it's a cliché, but I take my inspiration from life (and the internet as well!). Music for me is essential. I also respond to photography and I like the interesting cinematographic styles and approaches found in films. I love to see that someone's idea has come from their soul, something that has been experienced as a feeling and emotion. These kinds of works are always memorable and that's what I ultimately admire about typography.

Although I'm a fan of the Swiss style of typography, I think it's too early for me to develop a specific style or technique in my own work. Now is the time for experimentation. I employ digital, photography and printed matter in my design work.

I don't have single approach to working. When creating new pieces I always follow the maxim: 'the message, the idea, the viewer'. I try to keep the process of design simple and closely related to the initial concept. It's always great to create something that will eventually be used by people. In the end, I believe that the purpose of design is to be functional. The challenge, for designers of all kinds, is to create something that they are happy with and that viewer understands.

I think that type will always be a part of human life, they will always go hand-in-hand.

MIHAIL
MIHAYLOV

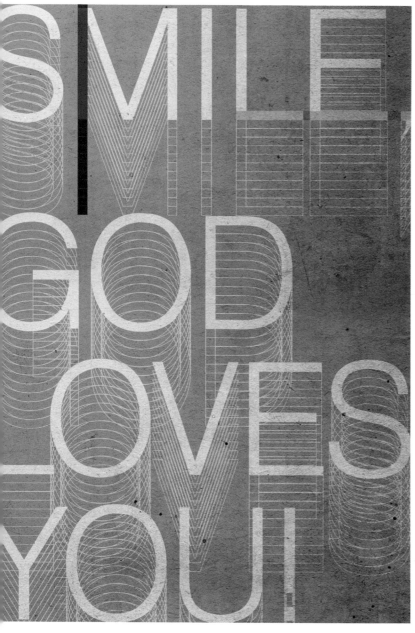

above:
illustration Smile
date 2008
media/techniques Adobe
Photoshop

right:
illustration Another Friday Night
date 2008
media/techniques Corel Draw,
Adobe Photoshop

44

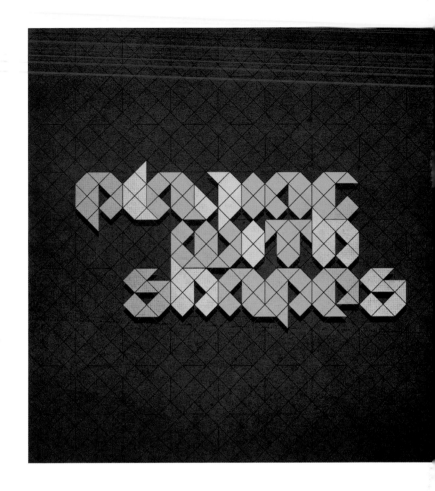

left:
illustration Modern Timing
date 2008
media/techniques Corel Draw,
Adobe Photoshop

above:
illustration Playing Again
date 2008
media/techniques Corel Draw,
Adobe Photoshop

PETAR PAVLOV

Birthplace: Kocani, Macedonia. *Education:* Accademia Italiana, Skopje, Macedonia. *Inspiration:* John Maeda, William Blake, Edward Bernays, Dante Alighieri, David Lynch, Michel Gondry.

The first 18 years of my life had nothing to do with design and typography. I didn't stand out as a talented artist but I enrolled at Accademia Italiana, the first school for graphic design and visual communications in my home country, Macedonia. After finishing the first semester, I got my first job at McCann Erickson as a graphic designer, a position that I still hold today. This was the defining moment in my career. Having the pleasure to work for clients such as Coca-Cola, Fanta and Bacardi amongst others, I gained a lot of knowledge and experience of my profession.

I am often taken aback by the amazing power of typography. People are confronted with letters on a daily basis and, by controlling the appearance of those letters, we can amplify or twist the meaning of a message. This can be seen in the works of typography masters like Paula Scher, Marian Bantjes, Philippe Apeloig, Adrian Frutiger and Wim Crouwel. They really know how to create a whole new universe for the viewer using letters.

However, the most influential person in my design career was one of my mentors, Gjoko Muratovski PhD. Muratovski taught me how to use design as a strategic device, not just as a tool for visual expression. This is the basic principle I apply to my design process. I always start by considering the nature of the project, trying to rationalize it. My goal is not to create something that I personally find aesthetically pleasing, but instead to create something that captivates the target audience. After I've given the project plently of thought, I start making sketches. For this phase, paper and pencil is usually enough, but sometimes I make paper models, digital collages or even experiment within 3D software. Each method leads to a different solution, so choosing the right one for the final piece of work is really important. The creative direction of the project is really bound by the client's brief. In fact, working within these boundaries is what gives me the most pleasure when the project is completed.

In the future I think that type illustration will become even more flexible. We will see it merging within all sorts of environments, taking on the attributes of real-life objects and situations. Even the typefaces will become much more interactive with the OpenType format. The designers will be able to make plenty of adjustments within the same typeface, thus creating endless combinations for potential use. The most important thing for all artists and designers is to continue experimenting on our own. Eventually we will push the limits of typography to another level without even realising how far we have come.

right:
illustration Fight Against Labeling
date 2008
media/techniques photography, Adobe Photoshop, Adobe Illustrator

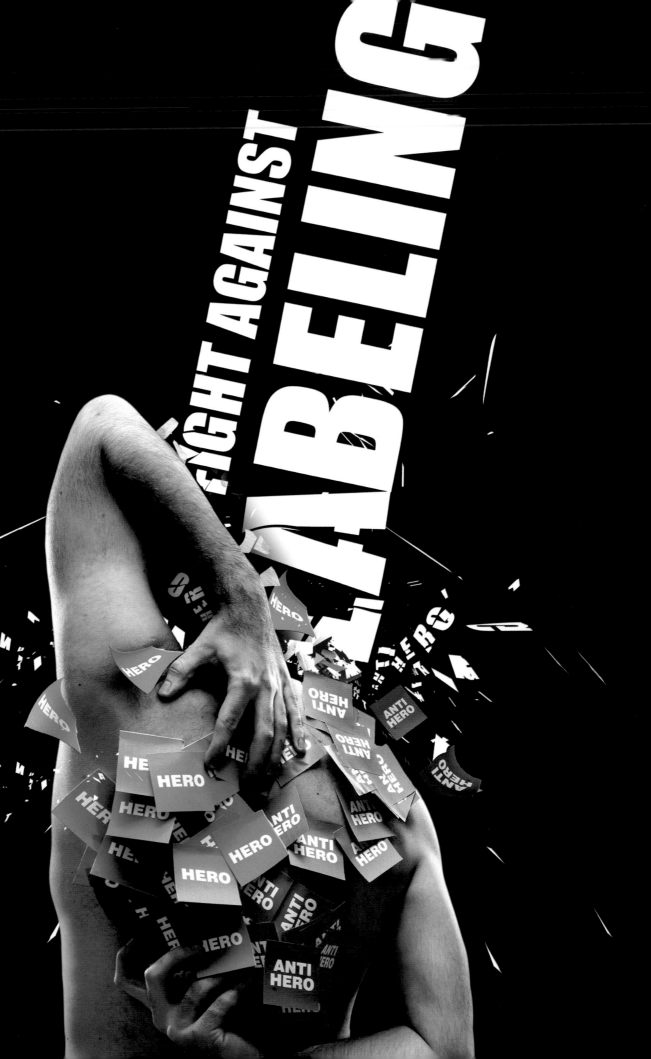

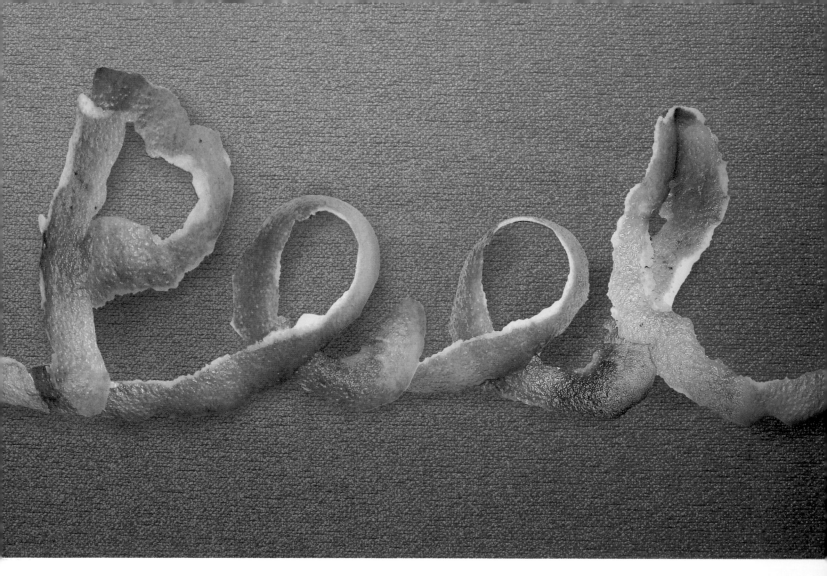

above:
illustration Peel
date 2008
media/techniques orange peel,
Adobe Photoshop

right:
illustration Fall
date 2008
media/techniques 3D Studio MAX

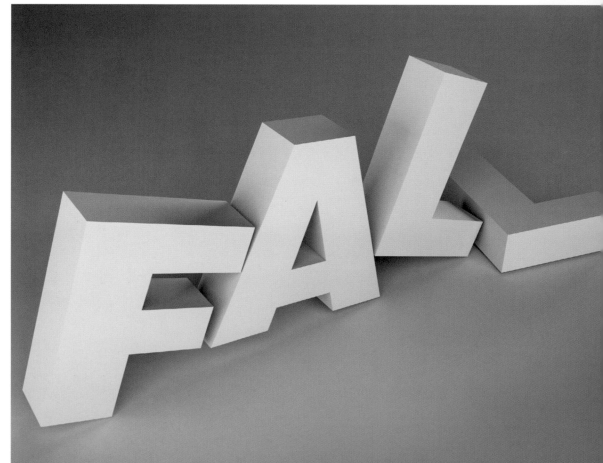

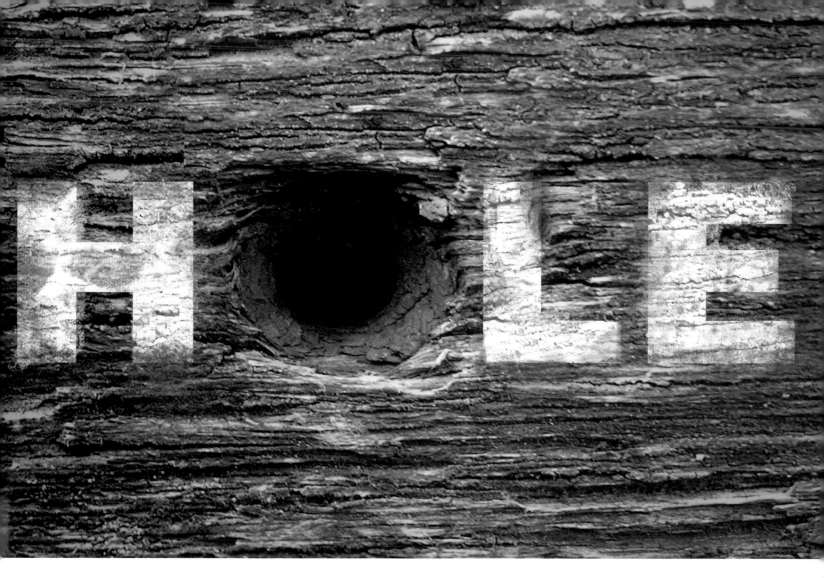

above:
illustration Hole
date 2008
media/techniques photography,
Adobe Photoshop

right:
illustration Dents
date 2008
media/techniques metal box,
photography

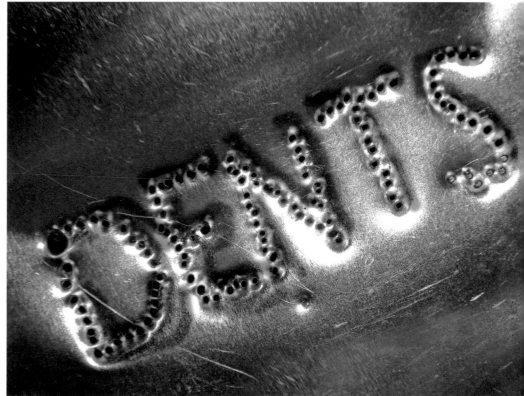

Birthplace: Targul Neamt, Romania. *Education:* The Academy of Fine Arts, 'G. Enescu', Iasi, Romania. *Inspiration:* Classical piano music, the Renaissance, photography, Frédéric Chopin, Leonardo da Vinci, Ellen Von Unwerth and Tupac Amaru Shakur.

I am a multi-disciplinary artist currently living and working in Bucharest as a lead designer and partner at the graphic design offices of Acme Industries. I've always been fascinated with the exploration of new shapes and new typefaces. Essentially, I have been involved with typography ever since I learned how to write and I later evolved towards graffiti, tattoos and eventually digital media.

I work with simple materials, usually starting with pencil and paper and followed by a lot of thought. It's this relationship between the process and the study that directs everything towards shape. My work often leads to me deconstructing classic typefaces. Grids and balance obviously hold an important role in this process. When reconstructing them, I always search for ways they can be improved.

The aim to create something complex and original is obvious but, most importantly, you want the viewer to be able to decipher your message. Typography has two main purposes: to communicate a message and to create an image. The observer sees them both but their reaction is dependent upon how he decides to interpret them.

I consider myself to be a visual person. I like to travel and to observe. I like drawing and listening to music, chilling outside with my friends, watching the sunset. I try not to spend too much time in the studio. I can work outside just by taking my notebook and a pencil with me. I get inspired by a lot of things – people, music. It can come from a random shape on the ground or from a magazine I've read. When you least expect it, inspiration will come, anytime, anywhere. In the streets, even in dreams, you can 'see' new shapes that fit your compositions.

I really admire artists like Herb Lubalin, Ian Brignell, Paul Rand, Marian Bantjes and Alex Trochut, because their work is so distinctive. Each designer acknowledges their legacy but pushes forward in new directions. Typography will continue to evolve as the mainstream always embraces anything that's cool. This is how magazines, videos and TV stations function. But good typography will always outrun trends and stand the test of time.

My advice to young creatives is this: do what you feel and don't pay attention to the trends around you. Keep experimenting. You can never know the real value of what you've just done. Don't be afraid of saying what you think. Find out what distracts you and eliminate it. Always try to simplify.

'Inspiration exists, but it has to find you working' (Pablo Picasso)

ANDREI
ROBU

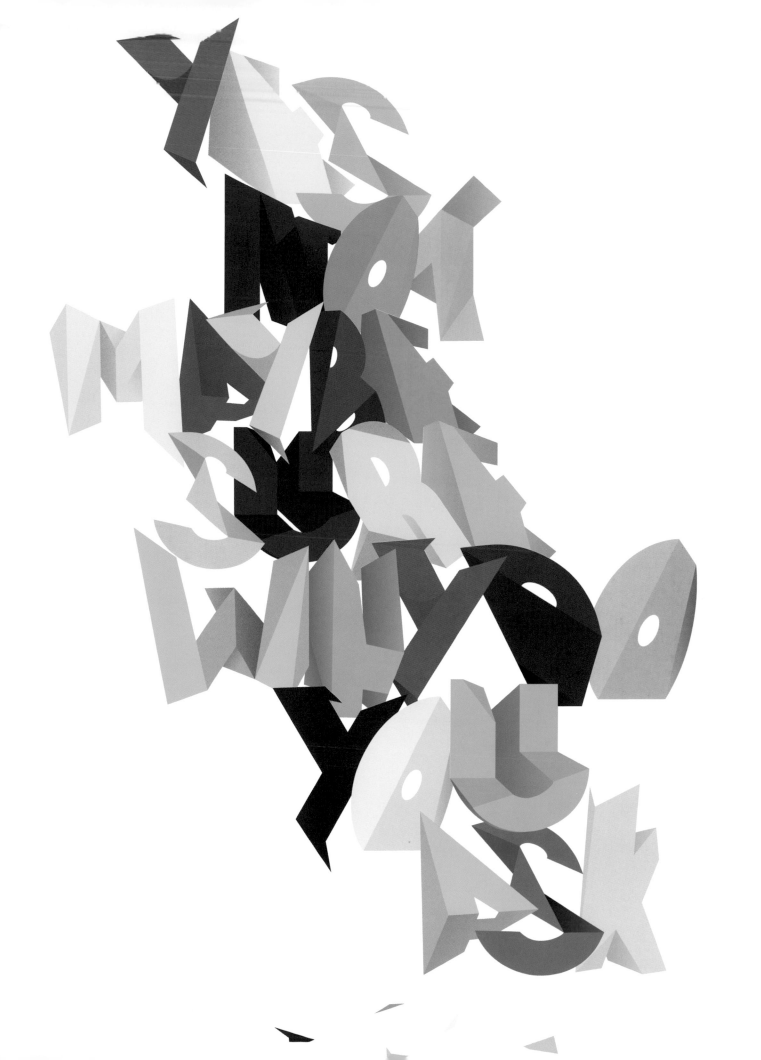

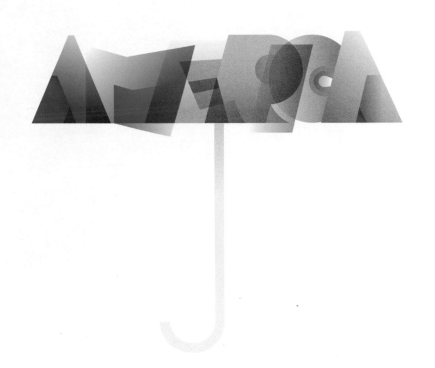

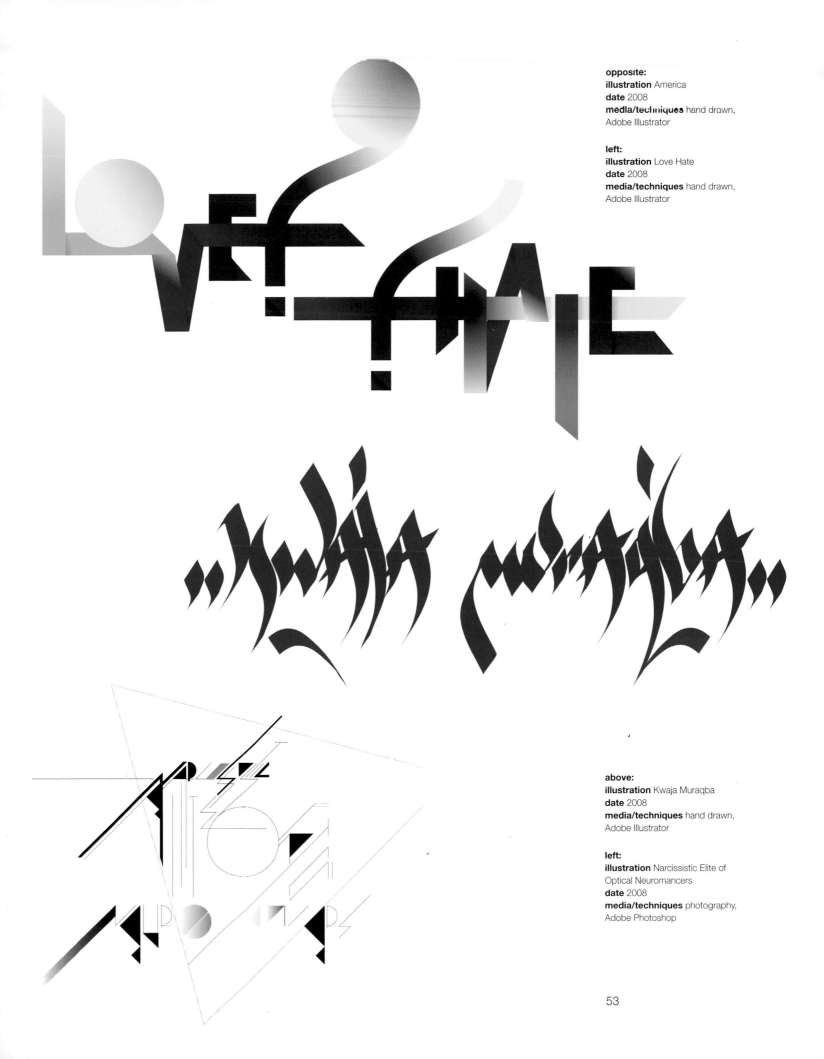

opposite:
illustration America
date 2008
media/techniques hand drawn,
Adobe Illustrator

left:
illustration Love Hate
date 2008
media/techniques hand drawn,
Adobe Illustrator

above:
illustration Kwaja Muraqba
date 2008
media/techniques hand drawn,
Adobe Illustrator

left:
illustration Narcissistic Elite of
Optical Neuromancers
date 2008
media/techniques photography,
Adobe Photoshop

SVETLANA SEBYAKINA

Birthplace: Kursk, Russia. *Education*: British Higher School of Art and Design, Moscow. *Inspiration*: Joseph Brodsky, Charles Dickens, Valentina Mukhina-Petrinskaya, Amon Tobin, Eduard Artemyev.

When I was six years old, my father showed me how to make beautiful and complex patterns by drafting them using a compass – I was immediately hooked have been totally adsorbed with art and design ever since. These days I am an art director at the Republica design studio, working on a variety of projects involving identity, branding and graphic design. All of them are commercial projects and our customers are both local and international companies.

At college I studied visual communication and type and typography. I like type because text is everywhere. Letters are just like faceted diamonds. I feel that I am able to take each letter and make it shine. As a form they have great graphic capacities.

Although today's digital equipment can make artwork richer and faster to complete, because of increasing technological advances I believe that the traditional approaches towards art and craft are more genuine and cleaner. By these methods, designs are generated more from the heart than from the mind. In my own work I rely more on art to create my work – technology only helps to improve the overall picture.

I take my inspiration from the world around me. It is very important for visual artists to look around to discover new and different things about their surroundings. This is an interesting exercise for both the mind and eyes. However, I also feel that it is important for every artist to have a muse. My own muse is just a single person – I won't identify him because then everyone will know his name!

I find films particularly inspiring. I love movies and, although I have a huge list of favourite artists, I am particularly interested in the work of the Russian film director Andrei Tarskovsky and the Canadian film director Guy Maddin. You only have to watch one of their movies to understand why they are so brilliant and inspiring.

Factors that have a positive effect on my work include time and the warm sun. Factors that adversely affect my work are impatience and closed minds.

When I begin work on a project I sometimes start with a pencil sketch, other times using photographs, and then it is just down to hard work. I am not too bothered about the final use of the design, its function or its commercial use. It is much more important as to whether the project is dull or interesting to me. While working on a current project I am usually thinking ahead about the next one.

I believe that type is set to have great future and its evolution will be very interesting to monitor even for those not directly involved with design. My advice to all future designers would be to absorb the entire world – take it all in!

right:
illustration December: Buenas Dias!
date 2009
media/techniques photography, buckled belt

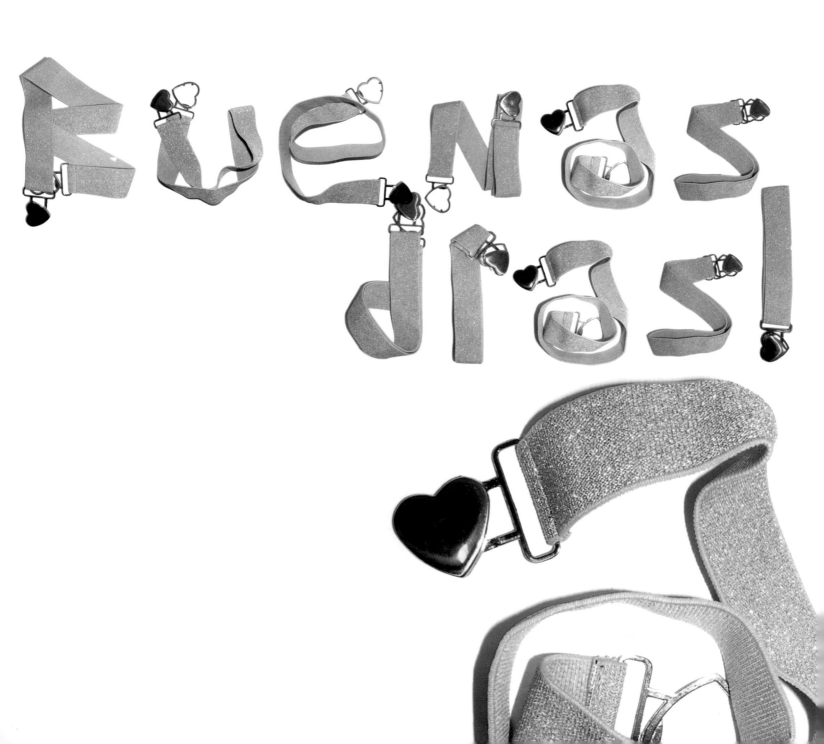

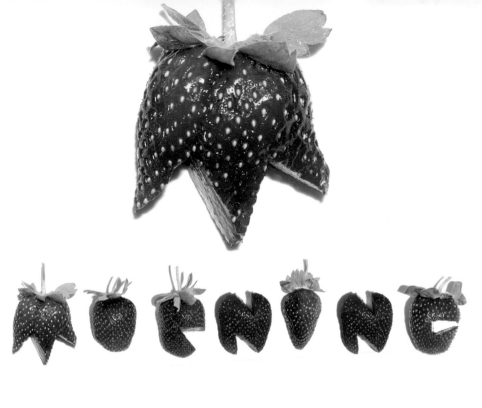

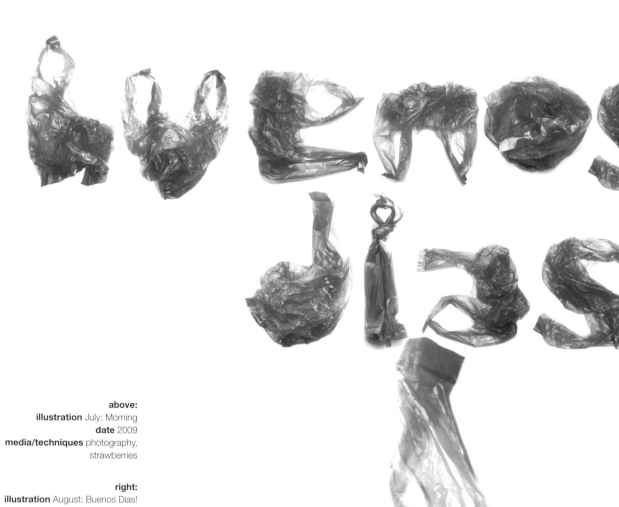

above:
illustration July: Morning
date 2009
media/techniques photography, strawberries

right:
illustration August: Buenos Dias!
date 2009
media/techniques photography, plastic shopping bag

56

left:
illustration March: Morning
date 2009
media/techniques photography,
alder fruit

right:
illustration November: Good
Morning
date 2009
media/techniques photography,
corrugated biscuit

Birthplace: Moscow, Russia. *Inspiration:* Graffiti, typography, Constructivism, science fiction, video games.

Sicksystems is a design collective. We share artistic interests and have a similar approach to the creative process. We operate as a group of freelance designers, working without studios or agents.

We were all graffiti artists and formed a crew in 2003. As time went by, felt we shouldn't limit ourselves to one art form and began to implement our style using other techniques and materials. Our formal art education hasn't had as much influence on us as graffiti and street culture, which came to Moscow in the late 1990s. One of us doesn't have an art degree at all, but it doesn't matter. We never made a conscious decision to become artists, it all happened quite naturally. We progressed step by step, starting with drawing in notebooks at school before making graffiti pieces, finally creating digital illustrations and 3D installations.

Lettering is the basis for all of our work. Graffiti is all about letters and these are the roots of our art. Although these days we make more and more artwork on the computer (as it is more convenient), drawing or painting by hand is still a great pleasure for us.

We are spurred on by the achievements of other people: artists, musicians, inventors and athletes – even businessmen. Their outstanding accomplishments are a great motivation for us.

They make us excited about creating new work. We like to stay focused on what we are doing and to move towards our goals gradually. We take our inspiration from everyday life and the endless stream of digital information around us. It is difficult to pinpoint a particular inspirational figure – everyone is great in his or her own way. Instead we're inspired by the many differing styles that exist, along with the development of visual culture in general.

The best ideas always come of their own accord. We always consider how the new artwork will be different from the previous ones. It is very important for us to develop and progress in everything we do.

Every single artwork begins as a pencil sketch. Then it becomes a vector image, piece on a wall, T-shirt graphics, canvas, or something else. The way our designs are used is really important to us; we always try to track how and where our designs are used and how our works are displayed.

Before we start working on a new design we consider all the restrictions of the brief. If there is too little space for creativity, we turn it down. If we find the boundaries acceptable, the creative process goes really smoothly.

Only true dedication brings good results. It is important to get totally absorbed in what you are doing and try not to think about the problems of everyday life. Always listen to your heart and move forward.

SICKSYSTEMS

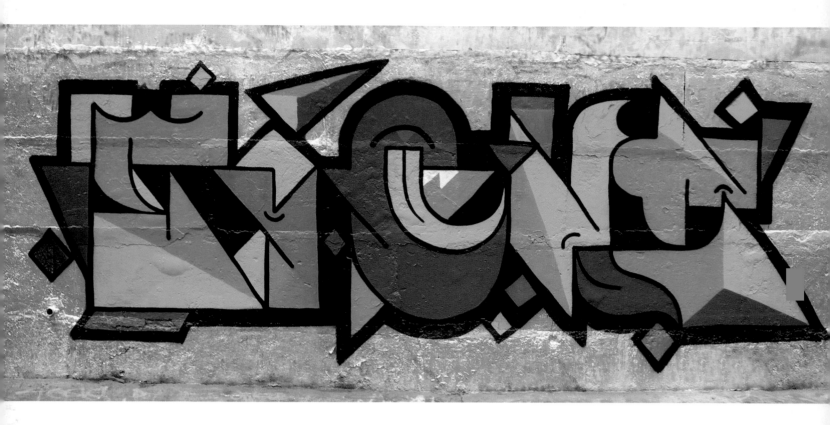

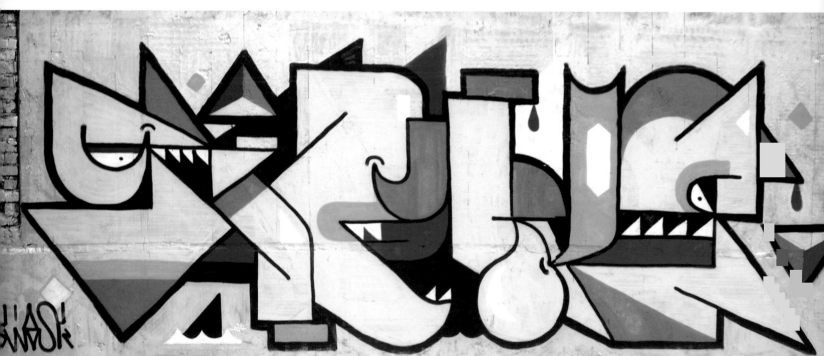

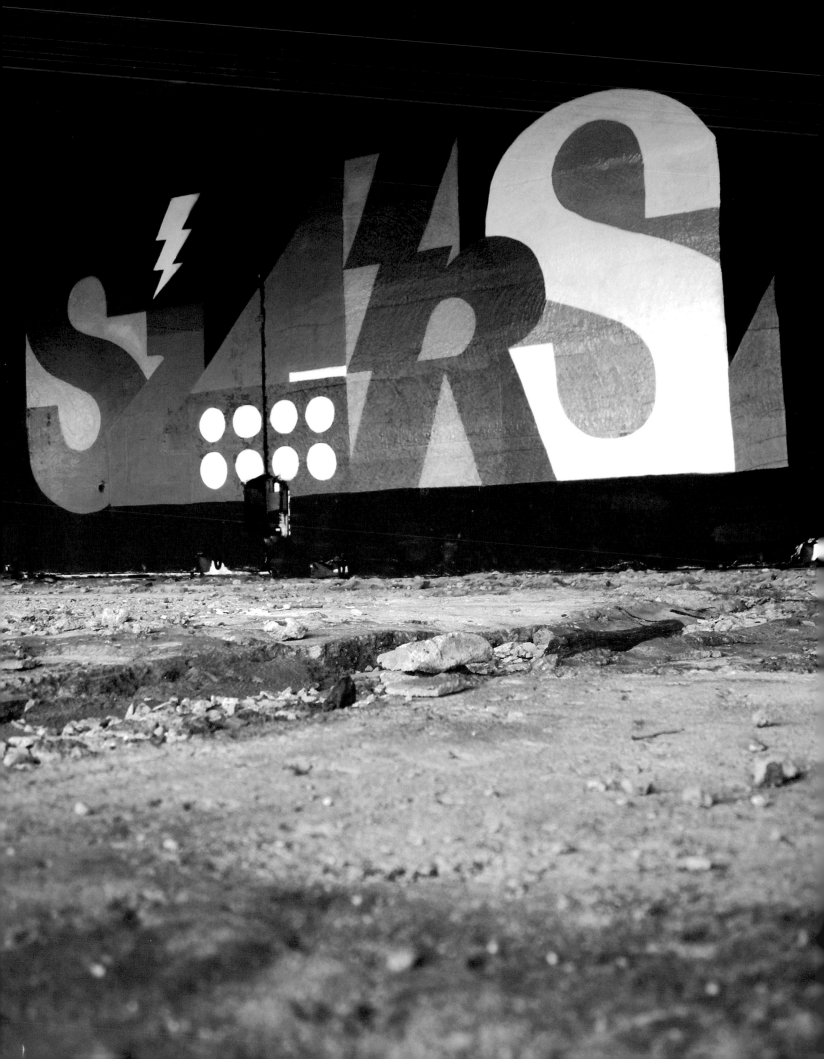

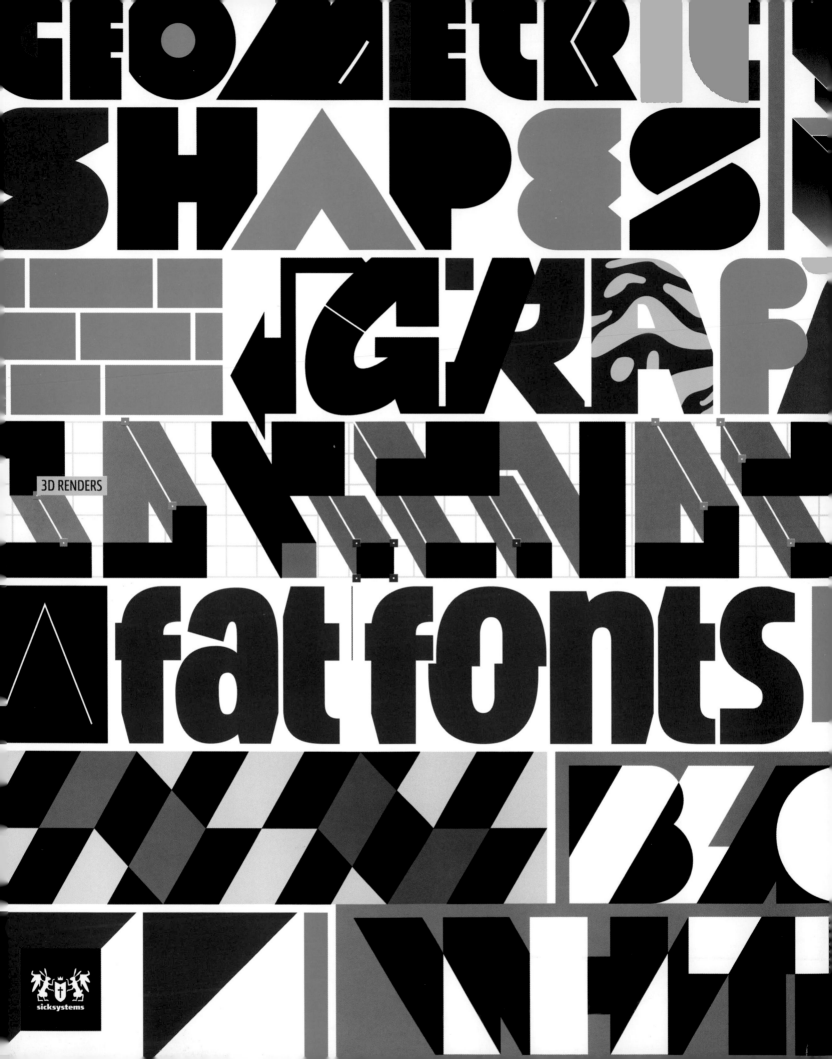

GEOMETRIC SHAPES

GRAF

3D RENDERS

fat fonts

sicksystems

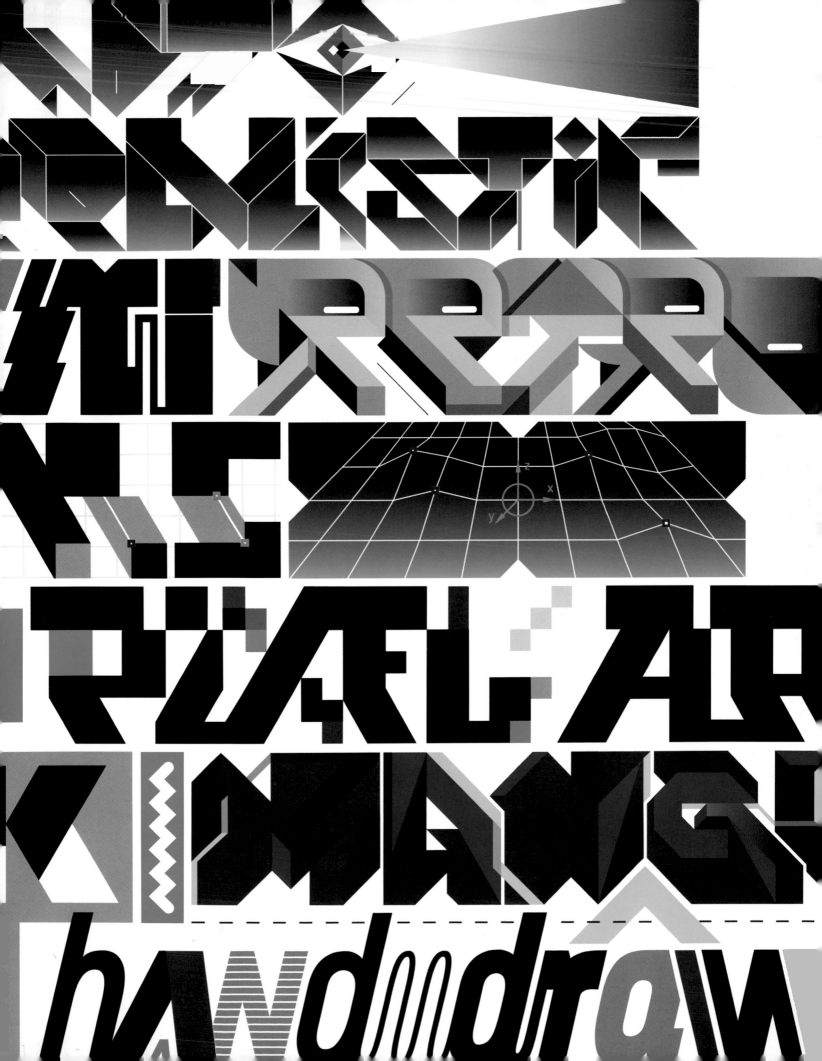

Birthplace: Greenock, Scotland. *Education:* Edinburgh College of Art, Edinburgh and London College of Communication, London. *Inspiration:* buildings, fine art, comics, posters, Modernism, Dutch graphic design, Nijhof & Lee.

I'm a designer currently working in London for a small studio that specializes in print and publishing. Originally from Scotland, I studied illustration at Edinburgh College of Art before becoming interested in type and typography and eventually focusing on graphic design.

A few years ago I completed an MA at the London College of Communication. Throughout the course, the main focus of my investigation was typographic ligatures. I was interested in how these special characters could be used in today's digital environment where language is often abbreviated and condensed. Email and text messaging have transformed the way we send messages but other technologies, such as text-recognition software and hand-held consoles, suggest that the handwritten letter may become a thing of the past.

Through my studies I have discovered many designers and linguists who have looked at ways of modifying the alphabet. Herbert Bayer and Jan Tschichold's Modernist alphabets of the 1920s for instance, through to more recent experiments by Philipp Stamm and Pierre Di Sciullo. I use an existing typeface, TheSans by Luc(as) de Groot, to create new ligatured characters which followed various criteria such as a fixed width or, where possible, a hand written construction. I also looked at different spelling proposals, phonetic alphabets and shorthand systems.

A key text was Herbert Spencer's *The Visible Word*, which should be required reading for any student of graphic design today. Another pertinent discovery was the *Initial Teaching Alphabet* of the 1960s, which was used to teach schoolchildren to spell using ligatured characters that represented common phonetic sounds (this included digraphs such as 'sh' and 'ng'). This system had mixed success but it was a brave attempt to address the challenges inherent in the present English alphabet.

The more you look into the history of the alphabet the more you can see how the form of letters has changed (or new letters have been introduced) to reflect developments in society or in the technology we use to write or print. The basic structure of our alphabet has not changed for a long time but it will be interesting to see where recent technological achievements take us. Will our alphabet become more simplified if we are no longer required to put pen to paper? Will the demand for speed and economy becomes greater than any aesthetic value we currently hold in type? As the internet creates a smaller world perhaps we will see a more universal language emerge, a common code or shorthand for us to blog, twitter and text to our hearts' content.

right:
illustration Shout/Sh
date 2008 (updated)
media/techniques adapted font
(TheSans by Lucas De Groot), Adobe
Illustrator, Fontographer

Shout!

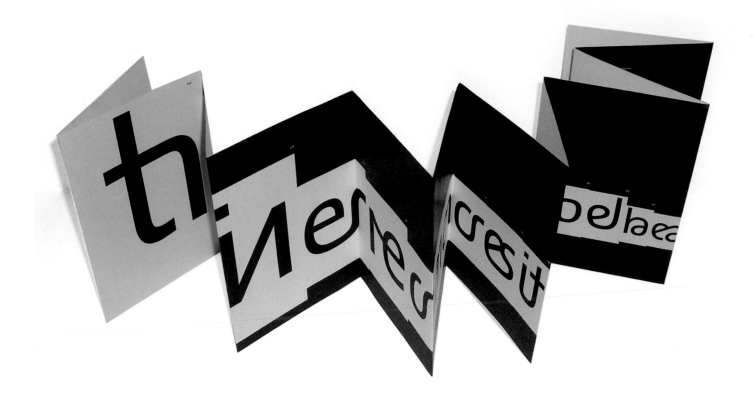

communication

kəˌmjuːnɪˈkeɪʃən

kæˌmyu_niˈkaʃæn

question

ꝗꞷeⴡ꭫

ꝗꞷeⴡ꭫

ꝗꞷeⴡ꭫

?

ABCDEFGHIJKLMNOPQRSTUVWXYZ

right:
illustration Frank Sinatra
date 2006
media/techniques hand drawn, gel
ink pen, watercolour, Adobe
Photoshop

Birthplace: Gomel, Byelorussia. *Education:* The Glebov Fine Art School, Gomel, Byelorussia. *Inspiration:* Fyodor Dostoyevsky, Vincent Van Gogh, Kuzma Petrov-Vodkin, Boris Vian, Takeshi Kitano.

I started working as a graphic designer when I was 16 years old and found that my skills were best suited to typography. I find hand-drawn typography both a difficult and exciting process. I felt a connection to typeface even before I became acquainted with computers. My parents had numerous coffee table books of Soviet art of the 1920s, when avant-garde artists used lots of text in their paintings. These paintings, with huge black lettering on the background, mesmerized me. I thought they were out of this world.

I believe there is a very thin line between the craft and art of typography. The Old Masters had a different attitude to type since they could make only a few letters a day from a metal press. Nowadays, using computers, it is possible to manufacture fonts (even entire families) in a few months. However, FontLab software and the OpenType format are only tools. I am not against digital methods but prefer not to use them. I don't use vector graphics, preferring the results of handmade illustrations.

I am inspired by my surroundings. I prefer not to create anything new but rather compile imagery using things that already exist. In the late 1960s, Herb Lubalin created the Avant Garde typeface and fashioned the famous logo for the eponymous magazine. I've recently seen a version of the logo, where a designer had used Times New Roman. Sure, it is a prank but I think it is genius!

I love the letter S. It appears in the dollar sign and the curves lend the letter a female silhouette. It is a great pity that it doesn't exist in Cyrillic. However, in the Latin writing of USSR and Russia it occurs twice so I do get to use it in my work! It is important for me to show my Russian roots in my work. Even for the smallest illustrations I try to include Cyrillic writing, or a Russian Lada car, or even a Kamaz truck.

My working tools are very simple: the cheapest ink gel pen from the supermarket and A4 office paper. Creating something new is always exciting! At first, there's only an idea, nothing substantial. But after a week there are dozens of sketches, collages in Photoshop and paper drawings. For me it is a case of while there is work, there is life.

My advice is to dig into history for inspiration, there is so much interesting stuff out there. In the last half century type has experienced so much mutilation, in particular the period following the mid-1980s. I would hope that we would learn from our mistakes. I think the present culture of typography will continue to evolve. It would be great if more people forgot existing fonts and started to create letters from other materials, such as old TV sets or potatoes.

FIODOR SUMKIN

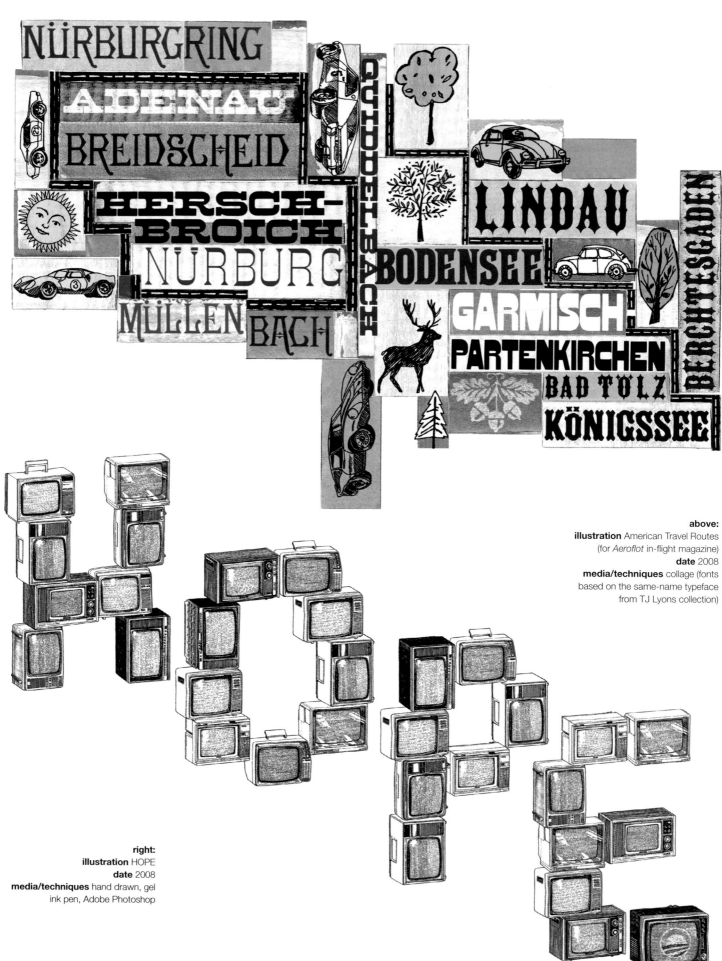

above:
illustration American Travel Routes
(for *Aeroflot* in-flight magazine)
date 2008
media/techniques collage (fonts
based on the same-name typeface
from TJ Lyons collection)

right:
illustration HOPE
date 2008
media/techniques hand drawn, gel
ink pen, Adobe Photoshop

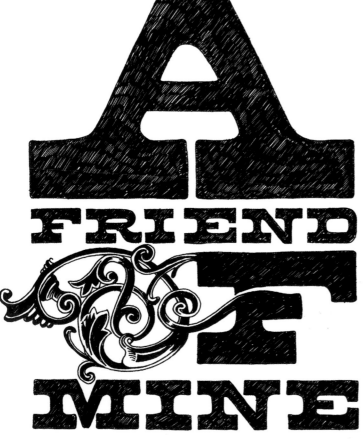

Birthplace: Barcelona, Spain. *Education:* Escuela TAI, Madrid; Eina, Barcelona; Elissava, Barcelona; Istituto Europeo di Design (IED), Barcelona. *Inspiration:* Hieronymus Bosch, Salvador Dali, surrealism, M.C. Escher, ukiyo-e, Keiichi Tanaami.

We are a design collective of 16 art directors, designers, animators and programmers. Father and son, Toni and Bruno Sellés, founded the studio in 1997 and a further partner, Enric Godes, joined the team a few years later.

We like to combine traditional and analogue methods with the latest digital tools to create a new and imaginative response. We still regard what we do as based upon craft rather than art but, although we love simple things, we can't always generate them. We find that it is a continuous struggle to achieve simplicity when our own nature demands that we create more and more complex things. We try to approach every project as a blank sheet and feel it is essential that we don't fall into the trap of repeating ourselves. We always try to maintain an open-minded philosophy and are never afraid to try out new things.

Illustrated type is now experiencing a new golden era and many designers are breaking new ground and establishing new trends and styles. For us the alphabet is an expressive form as powerful as any other visual medium. Letterforms can be used to convey feelings in either very subtle or very outspoken ways. Using text in this way you can create a meta-message that enforces (or contradicts) the meaning of the text itself.

We employ different working methodologies depending upon each project. Usually it begins with hand-drawn sketches and ideas that we scan and later, via computer software (Adobe Illustrator or Adobe Photoshop), redraw and colour. We also import documentary images to add detail to the artwork – perhaps a whole picture as a basic image to paint over or just textures and abstract things to decorate parts of the composition. It is always important to fully identify in advance what kind of visual conclusion clients want to achieve so that we don't disappoint them. When we have complete freedom, we can do strange things – the kind of things we like the most– but sometimes this is not necessarily what the client expects.

Understanding when the piece is finished is an intuitive process – it seems to stand out and announce: 'done!' Sometimes, when you have to work to a very tight deadline, you may not have enough time to try out experimental things or treatments and you feel that with a little bit more time it could look even better – but this is always the dilemma with short deadlines.

Budding illustrators should embark on their chosen path because they're passionate about being part of the world of design, not for the money. You will probably still get irate when your mother says, 'you actually get paid for doodling these things?' – but it's worth it in the long run.

right:
illustration The Room Flyer
date 2006
media/techniques Adobe Illustrator

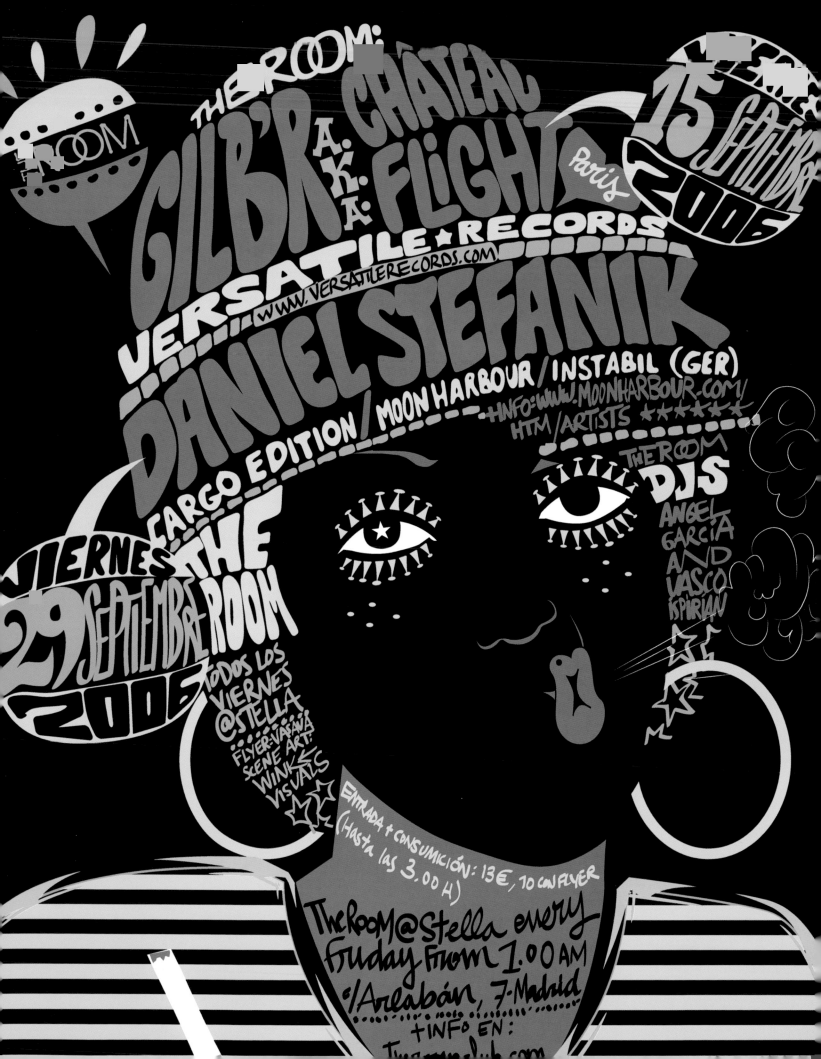

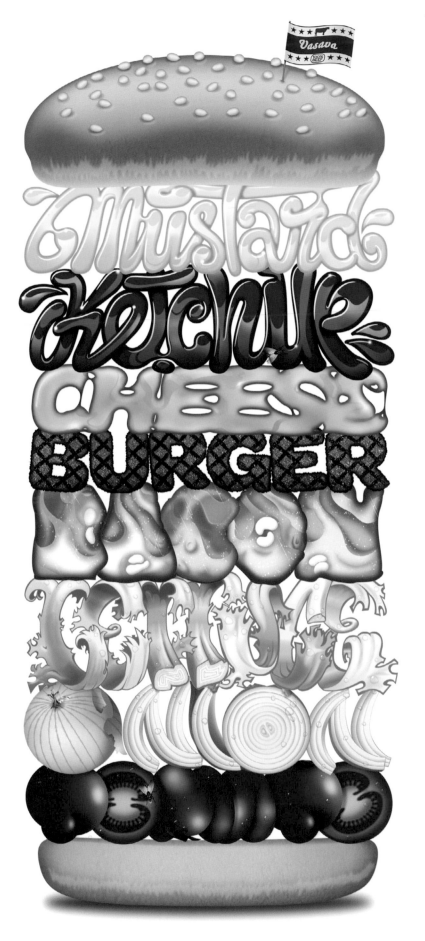

far left:
illustration Modular Burger
date 2007
media/techniques Adobe
Photoshop, Adobe Illustrator

left:
illustration Shots, Blood & Girls
date 2009
media/techniques Adobe
Photoshop, Adobe Illustrator

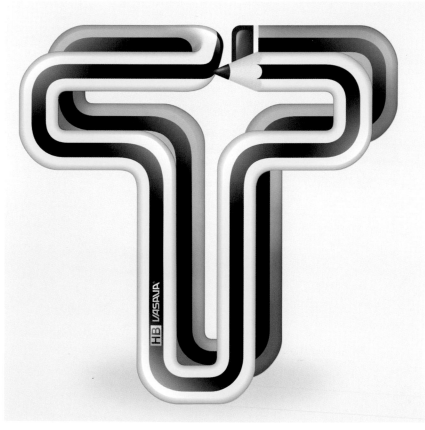

above:
illustration ID-Diesel
date 2007
media/techniques Adobe
Photoshop, Adobe Illustrator, 3D
Studio MAX

left:
illustration T
date 2009
media/techniques Adobe
Photoshop, Adobe Illustrator

right:
illustration Alphabet Cities Series:
New York
date 2007/08
media/techniques letterpress,
Adobe Photoshop

Birthplace: Boston, Lincolnshire, England. *Education:* Buckinghamshire Chilterns University College, High Wycombe. *Inspiration:* Herb Lubalin, Saul Bass, Alan Fletcher, Chris Ware, Christoph Niemann, Si Scott, Alex Trochut.

Growing up, I had little idea that there was any way I could make a living out of graphic design, but I always found myself gravitating towards the art department at school. I had an enthusiastic tutor who taught me the basics of typography while introducing me to the work of Jan Tschichold, Eric Gill and Herb Lubalin. I am now a London-based designer and illustrator who enjoys playing with words. Currently employed by the advertising agency CHI & Partners, I also work from home trading under the pseudonym Words Are Pictures. Unlike a conventional illustrator, I can use as many styles as there are typefaces and as many different treatments as I can think of. The combinations available are limitless, which is why I find type so exciting.

My inspiration comes from all manner of places; films, photographs, a passage of text, a line in a song, an article in the paper – anywhere a series of words jump out at me and ask me to tell a story. I look for situations where type is doing something you might not expect: a badly stencilled sign on a building site, a misprinted poster, a poorly painted shopfront or a broken neon sign can all be re-appropriated to help convey the meaning behind words.

I use digital and traditional methods in my work. My first wave of commissions were all completed using a letterpress that I bought after I graduated. I also experimented with other methods – hand-drawn type, linocut and much more. I always like an element of craft in my work. I think it's important to know that a person was involved. My letterpress is always great to work with because it's kind of broken and you never get that perfect print. You just have to let go and run with what you get. I like turning over a certain amount of responsibility to the process and seeing what happens.

Every single brief I accept from a client starts in my sketchbook; it's the only way I know how to work. I look for relationships between letters and spend lots of time playing around, doodling on them, adding to or taking away from them and starting to decide what I want to do for a final piece. From there it grows organically and can become a print, a paper cut, a photograph ... whatever really.

The future of typography is inevitably heading towards the screen. Print is by no means dead but there is so much really cool, interactive work out there. For hundreds of years we only had one single way to interact with type but now we can pull it around, grow it, shrink it, squeeze it, and view it in three dimensions. People will always need type and typography because we all love to, or need to, read in whatever capacity. For that reason, it will be around forever.

CRAIG WARD

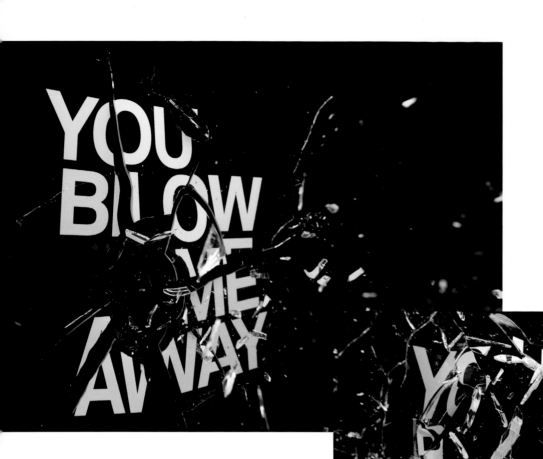

below:
illustration You Blow Me Away
date 2009
media/techniques photography

below:
illustration FontLab Photofonts:
Hirsutura
date 2008
media/techniques hair, Adobe
Photoshop

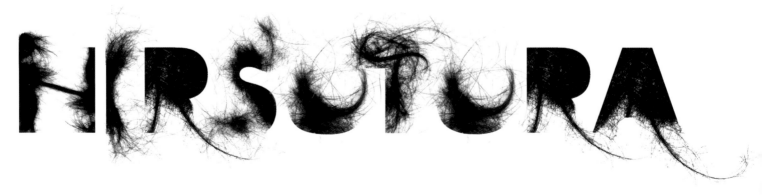

below:
illustration FontLab Photofonts:
Blossomwell
date 2008
media/techniques blossom, Adobe
Photoshop

THE
SCI
RO
OFS

above:
illustration The Science of Sex
date 2008
media/techniques Adobe Photoshop

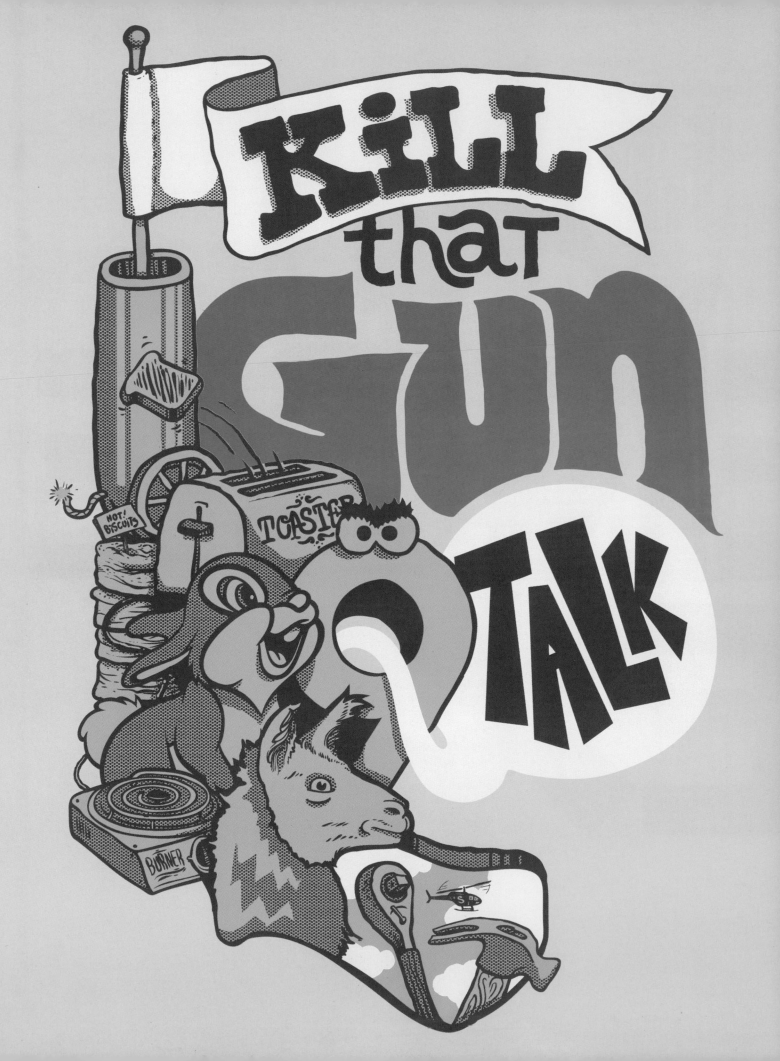

AMERICAS

EMANUEL COHEN

Birthplace: Montréal, Canada. *Education:* Concordia University, Montreal, and Université du Québec à Montréal (UQAM). *Inspiration:* Josef Müller-Brockmann, Paul Rand, Robert Doisneau, Margaret Bourke-White, Stan Getz, Ali Ibrahim 'Farka' Touré.

I was exposed to art and design from a very young age as my parents were both involved in the disciplines. While studying communications in college, I had the chance to explore a wide variety of artistic fields (photography, drawing, sculpture, and so on) and found that design was the one field where I could combine all of these activities. Typography and microtypography in particular satisfy my meticulous nature.

I particularly admire the Swiss International Style of design. All artists from that time inspire me and I always try to apply the design theories instated by these artists to my work. Clarity, organization, rhythm and contrast are all integral to typography.

Type is a visual medium that can be treated in an infinite number of ways – it is limitless. It is important to learn the rudiments of any craft before it can become art. Good or proper usage of type is an art in itself. I enjoy a mixture of working methods. Although I commonly work via digital methods it is important to get my hands dirty and experiment with traditional methods as well. Working by hand is very liberating; there is no intermediate between your brain and your 'canvas'. It is also a crucial step in getting your ideas out and testing them quickly. I think that working directly on a computer stifles creativity. I like to see the computer as my 'put everything together' tool.

When I create an artwork I usually fill three or four pages of my notebook with random notes and scribbles to organize my thoughts. Then I begin sketching out my ideas, trying out colours and so on. Once I start to sense I have something taking shape, I start testing it out with more detailed drawings or on the computer. I have recently started using the photocopier as a tool for creating new images because I enjoy the texture it adds to visuals. I try to consider my audience when I create a design and I always try to leave something to decode. Interaction with the viewer is very important.

Type will always be an excellent source for experimentation; you can make letters out of almost anything, which leads to creating new trends in graphic design. Although designers enjoy experimenting with type, we will always enjoy the beauty of traditional type and its principles. Wherever typography is heading, I believe it will always return to its starting point.

I believe that learning about the past of design is very important, studying the evolution of design up to what it is has become today. People often emphasize the importance of learning how to use technical software but it is important to understand that design and creativity doesn't come with the computer.

right:
illustration Typo Grillé
date 2008
media/techniques collage

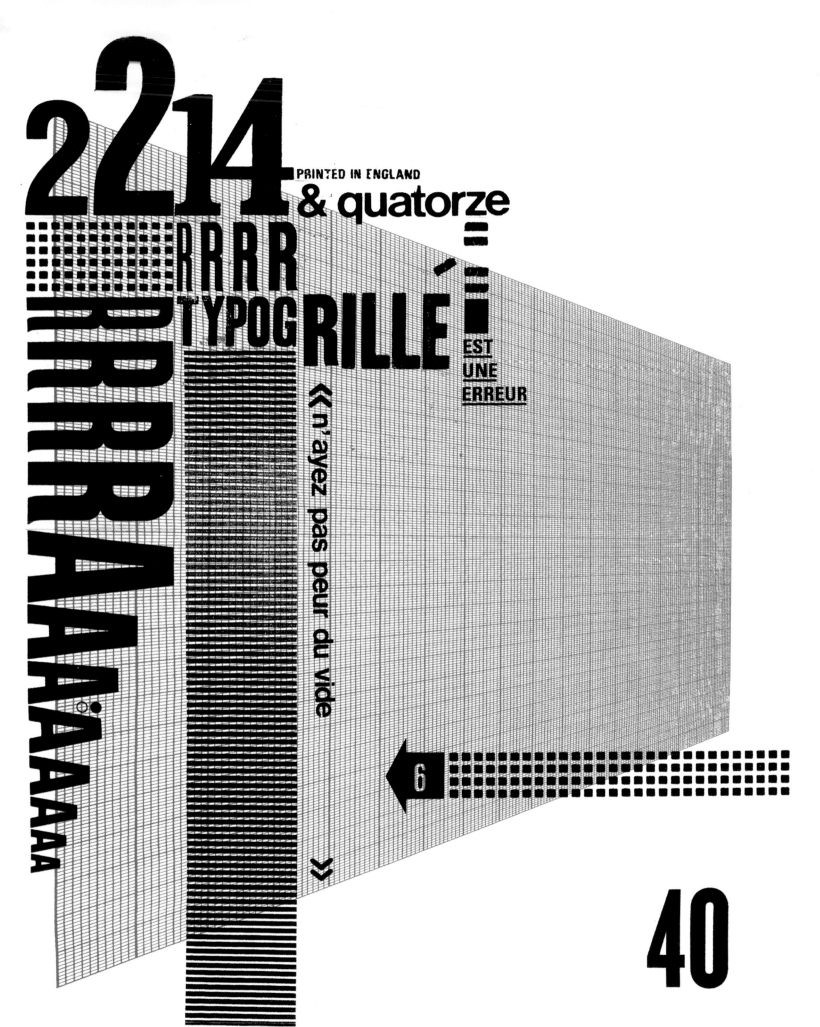

2 2 14

RRRR
RRRR
RRRR
AAÄÄ
ÄÄÄA
AAAA

PRINTED IN ENGLAND

& quatorze =

TYPOG RILLÉ

=

EST
UNE
ERREUR

«n'ayez pas peur du vide »

6

40

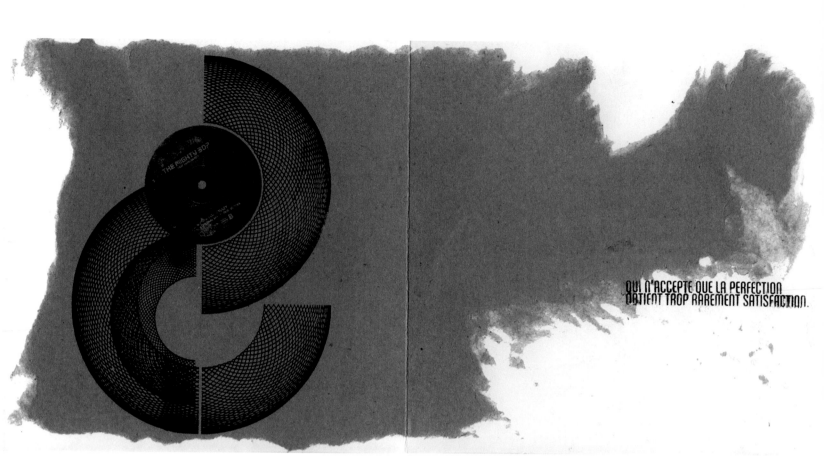

QUI N'ACCEPTE QUE LA PERFECTION
OBTIENT TROP RAREMENT SATISFACTION.

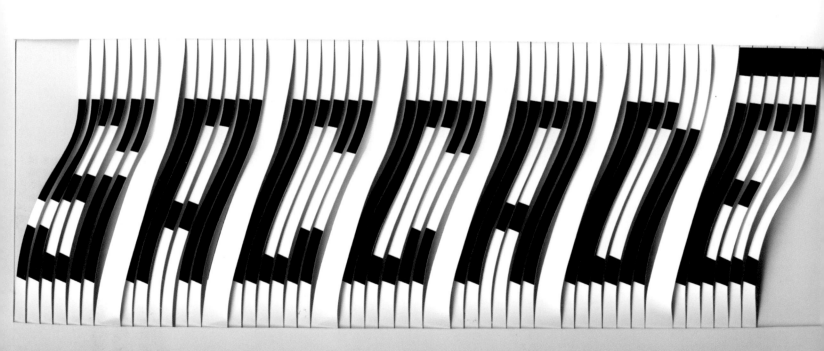

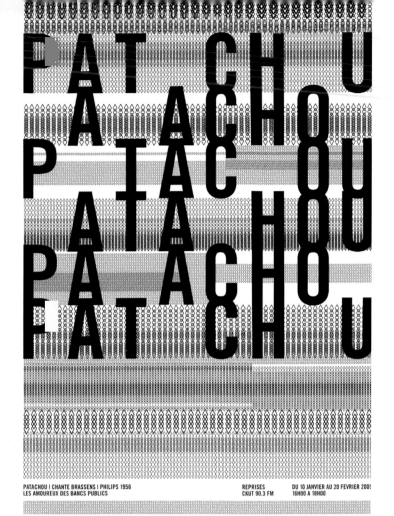

PATACHOU | CHANTE BRASSENS | PHILIPS 1956
LES AMOUREUX DES BANCS PUBLICS

REPRISES
CKUT 90.3 FM

DU 10 JANVIER AU 20 FEVRIER 2009
16H00 A 18H00

opposite, top:
illustration Self Portrait E
date 2008
media/techniques Kenner's
Spirograph, screen print, kraft paper

opposite, bottom:
illustration Saccadé
date 2008
media/techniques Adobe Illustrator,
hand cutting

left:
illustration Patachou
date 2009
media/techniques Adobe Illustrator

below:
illustration Le Répondeur Urbain
date 2008
media/techniques scanned
woodtype prints, Adobe Photoshop

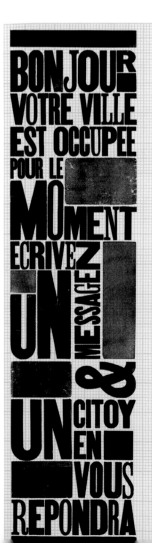

right:
illustration Bedlam Ballroom
CD Cover
date 2000
media/techniques Adobe Illustrator

Birthplace: Brooklyn, New York. *Education:* Cooper Union School of Art, New York. *Inspiration:* Morris Fuller Benton, El Lissitzky, Adolphe Mouron Cassandre, Stenberg Bros., Edward McKnight Kauffer.

I grew up in Brooklyn, New York, near the tattered remains of that wonderful old collection of amusement parks known to the world as Coney Island. At the time, my dad worked for MGM Pictures in Times Square, known in the area as 'The Great White Way', and I visited him often. I cannot help but feel that the inspiration for my work came primarily from my early years growing up near the bright lights, signage and brilliant colours that I found near my Brooklyn neighbourhood, and which also surrounded my dad's office. Later in life I found similar inspiration echoed in such diverse sources as enamel signs, matchbook covers, packaging and the numerous and varied artifacts of the mid-century America I grew up in.

When I graduated from the Cooper Union School of Art, I realized that I was no Roy Lichtenstein, so went straight to a job as Ed Benguiat's assistant at the now famous and long defunct typesetting house Photo-Lettering. After several years at different staff positions I went on to start my own design studio in New York, specializing in letterform art. In my work I revitalize the art of hand-lettering by expanding it into, and integrating it with, the disciplines of illustration and graphic design. Initially my work inspired many imitators, many of whom have gone on to make their own contributions to the art form. Together with my wife, illustrator Laura Smith, I now run my studio out of my home in the Hollywood Hills of Los Angeles.

For many years I concentrated almost exclusively on logo and lettering projects but recently I have expanded the base of my work to include font design by opening my own digital type foundry Alphabet Soup. I have recently completed designs for five unique fonts and font families, and I expect to expand my offerings soon. I've come to learn that font design is quite different from working with lettering and logos. It's actually a whole world with its own rules and restrictions and it's taken me quite a while to get up to speed in it – despite my long history of working with letterforms.

The kind of work that inspires me is (with exceptions) usually vintage ephemera of one type or another. The work I gravitate towards usually displays a joyous lack of regard for convention and 'the rules of design'. I imagine that the artists who did this work were just doing what came naturally – they may not have known the rules, so how could they have known they were breaking them? It is these 'mistakes', these flourishes – typographic and pictorial – which I find so engaging and which I've tried to pay homage to in my own design work.

MICHAEL DORET

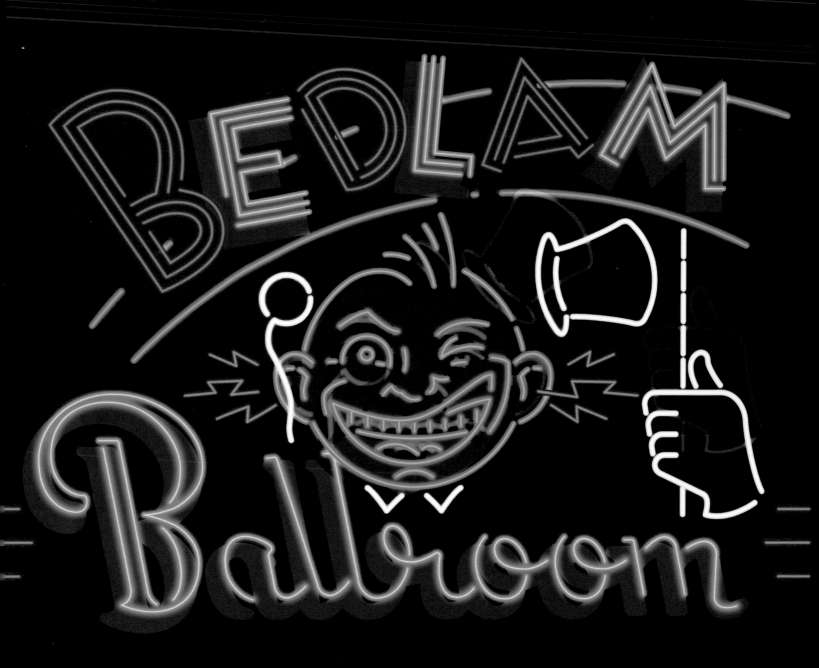

above:
illustration NT Knicks Logo
date 1991
media/techniques Adobe Illustrator

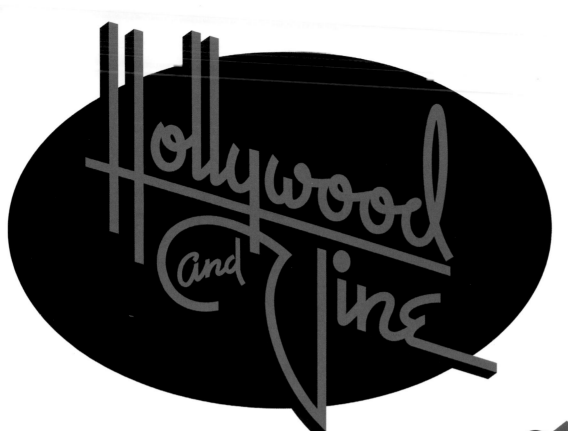

left:
illustration Hollywood and
Vine Logo
date 2000
media/techniques Adobe Illustrator

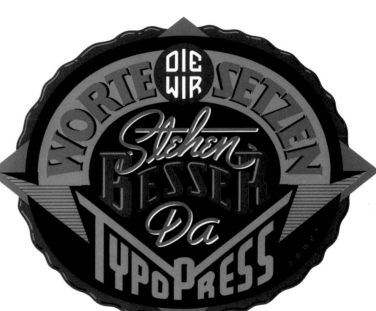

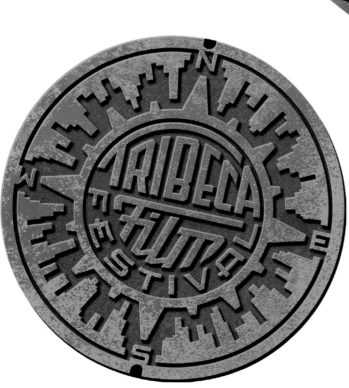

above:
illustration Typopress Logo
date 1990
media/techniques ink on
drafting film

left:
illustration Tribeca Film Festival
date 2006
media/techniques Adobe Illustrator,
Adobe Photoshop

JESSE HORA

Birthplace: Michigan, USA. *Education:* Grand Valley State University, Grand Rapids, MI, USA. *Inspiration:* Alphonse Mucha, Milton Glaser, Larry Bird and my mother, Sharon Hora.

I'm currently working and living in Chicago as a freelance illustrator and art director known as Jesse Hora Dot Com. The main goal of my work is to communicate a message; if the message is not clear, the work is useless.

I have always been a happy-go-lucky kind of guy and I think that is apparent in my work. I always knew I would take a creative career path. My family is talented in creative and visual areas, so it was just a matter of finding my own creative outlet. One of my greatest pleasures is vintage candy packaging. As a kid I loved looking at old junk with my grandpa and my fascination with old things continues to inspire me today. Inspiration for me is the easy part of what I do; I gain inspiration by living my life and trying to look at things with fresh eyes every day. Although I prefer hand-drawing rather than working on the computer, the biggest influence on my work would have to be the internet. It allows me – and my entire generation for that matter – to see things I would never have had the opportunity to experience in the past.

Type is beautiful! When type is done well it can take design or illustration to the next level.

Type gives you the opportunity to incorporate layers of meaning into your work that you cannot achieve with pictures alone.

I normally work in a mixture of traditional materials like paper, pencil, marker, paint, as well as digitally via Adobe Illustrator and Photoshop. Most of the time I will start with a super-quick doodle, just to get the idea out of my head and down on paper. Depending on the idea or concept I will need to do some reference research to figure out how the image 'works'. If something isn't working or doesn't make sense I will draw it a few times to refine the details. Once everything comes together and makes sense I will draw it perfectly one last time. Normally everything has been thought out by this point, so the final stage is just a matter of manipulating the colour, texture and other elements via Adobe Photoshop and Illustrator to get the perfect finish.

I can already see that the next trend in type will be combining illustration with typography. I always try to create good work – that's the key to success in this industry. The biggest mistakes I see from student and newcomers is that they imitate their idols. Instead of studying what make that person special, they will simply copy or mimic that style or look. What is needed is inspiration, not imitation.

right:
illustration Sehubabe
date 2009
media/techniques pencil, Adobe Illustrator

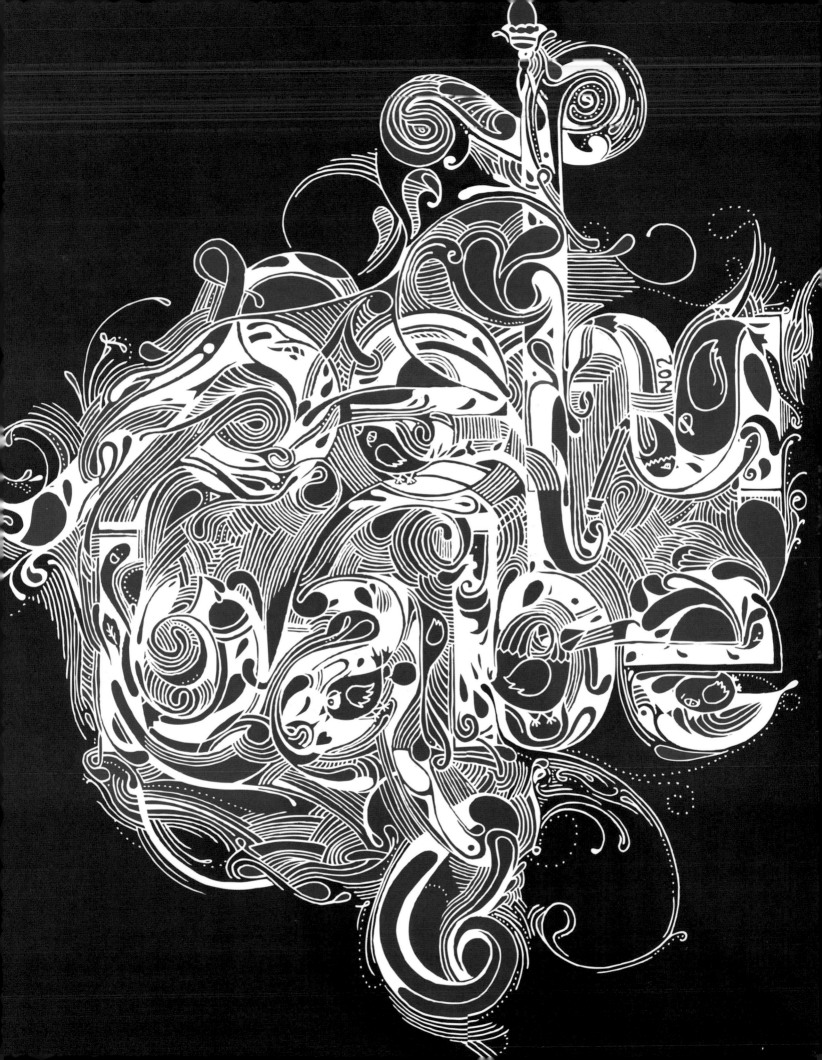

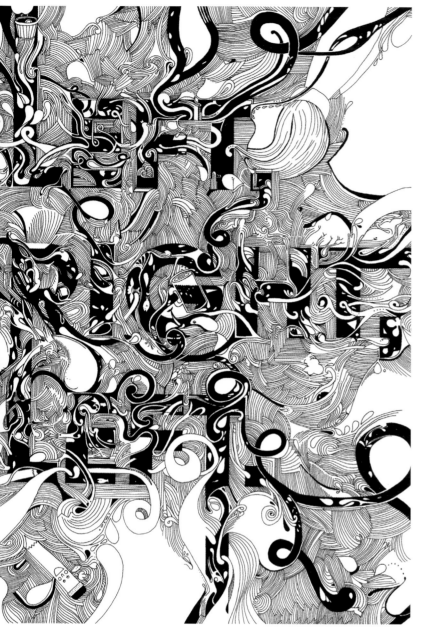

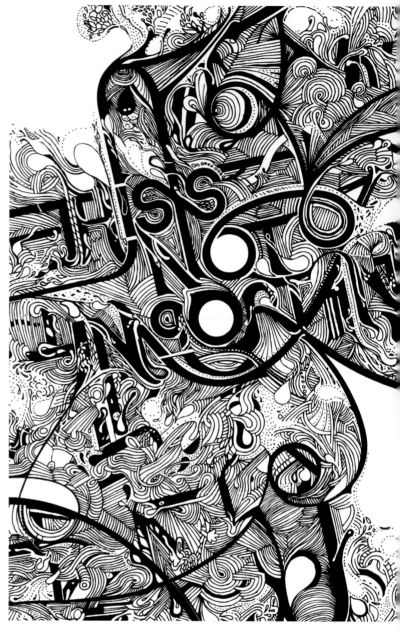

This is

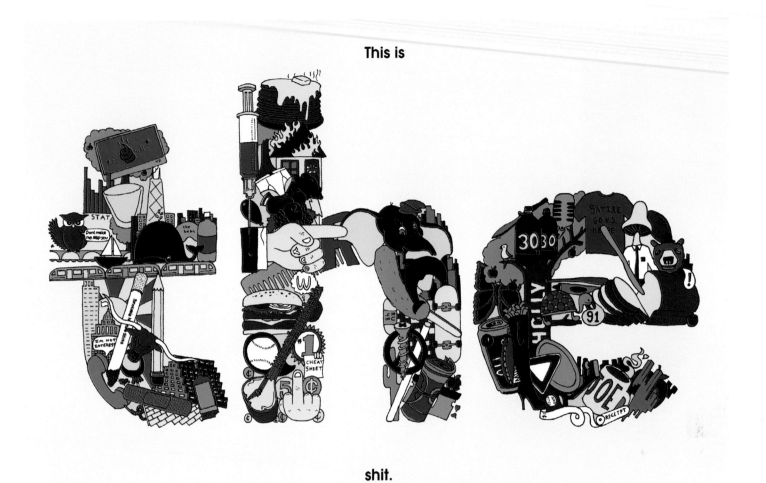

shit.

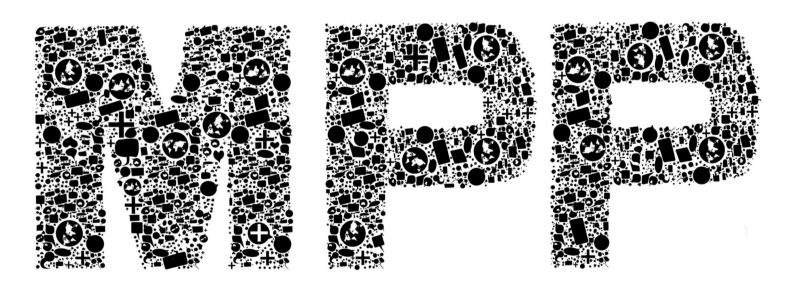

Birthplace: Seattle WA, USA. *Education:* BFA University of Washington, Seattle. *Inspiration:* John Cage, William A. Dwiggins, Rainer Maria Rilke, Jim Dine, Romare Bearden.

I grew up as an avid reader and wanted to be a writer. Because what we now refer to as 'content' was my first love, my philosophy as a graphic artist has always been driven towards lettering design. My primary loyalty is to the writer and the meaning of the words, and I put that first. I approach each project as an actress. I want the reader to hear the writer's voice and feel the words as much as see them. My vehicle is the energy and quality of the marks on the page. Although I admire virtuoso calligraphic technique it can become athletic display or decoration, competing with or obscuring the content. My perverse task is often to eliminate beauty, while stumbling across the accidental, the artless and the authentic.

I have an extensive background in western calligraphy, Asian brush writing and *sumi-e* (ink painting). I spent many years practicing different classical forms, learning every major hand from Carolingian to Batarde and Spencerian script, and writing tsutras and plum blossoms on thousands of sheets of rice paper. I have been an artist since I was 18. The painter in me always objected to making more than a few letters or leaves or flowers in the same consistent style and so following tradition was not my natural path. When I found my way to logo design and expressive lettering design for advertising I felt like I had found the perfect marriage of fine art, literary interest and design.

I divide my time between a career in design and my fine art. I use letters at times in my personal work and journals, but the alphabet is incidental to my interest in symbols themselves and the space between symbolic representation – how we actually see and how we make meaning. I work in many media in my fine art and, as with my design life, the meaning of the work takes precedence over a personal identity of style.

Although I create a lot of formal typographic lettering for book covers and corporate identity, the emphasis lately has moved in the direction of free-form calligraphic work. The impersonality of the computer has sparked a counter-trend towards expressive design that communicates the human hand, voice and personality. It is an exciting time to be involved in letterforms. I am looking forward to collaborations with people working in the growing fields of animation and online advertising, as well as in print.

ISKRA JOHNSON

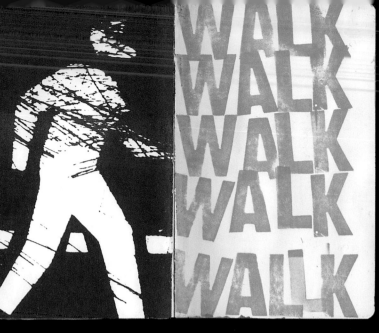

WALK WALK WALK WALK WALK

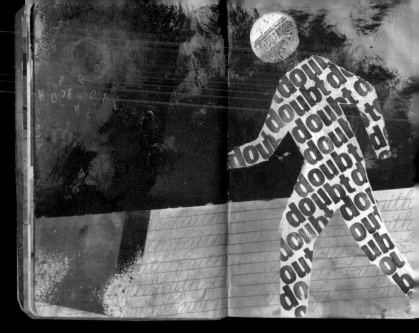

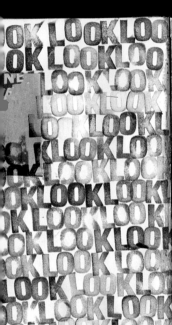

LOOK LOOK LOOK...

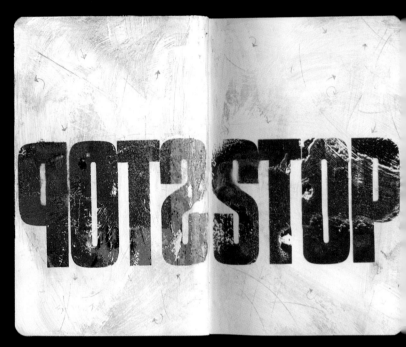

STOP

on

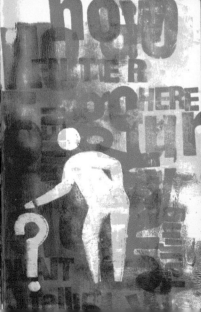

NO
WHITER
HERE
?

Thus planets stay in their
orbits because a linear for
that would propel them eve
farther away balances a g
vital bal force that woul
pull them into the sun just
the stability of time's cycle
balances destruction and
novation. Planetary motio
also establish a set of sho
er cycles forming abunda
material for metaphor:
seasons, and all the repe
described by Hutton under
general rubric of the fu

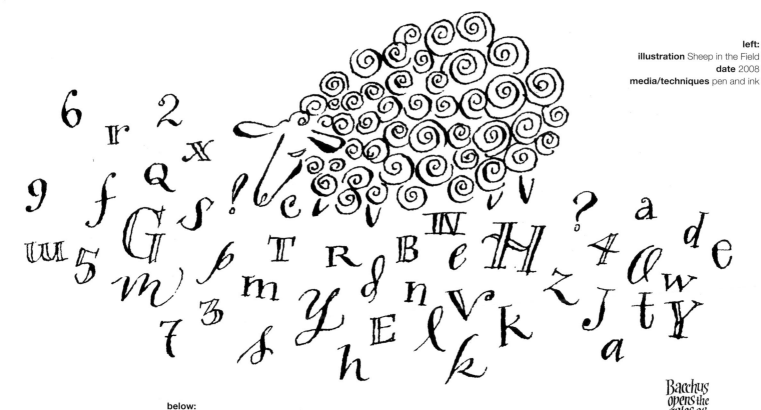

left:
illustration Sheep in the Field
date 2008
media/techniques pen and ink

below:
illustration Wine & Thou
date 1996
media/techniques ink

right:
illustration Wine Is Life
date 2000
media/techniques pen and ink

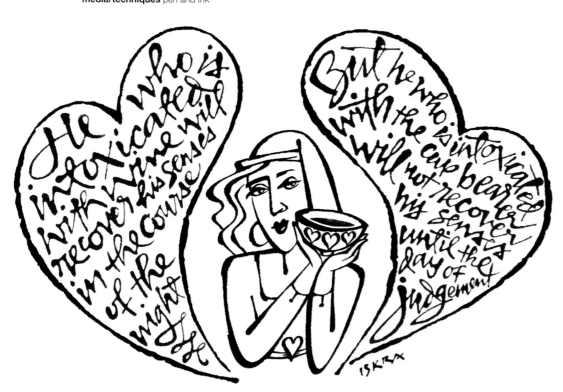

i RUN for Myself. each step of the way. i DREAM of toMorrow CHERiSH & YESTERDAY. My Soul opens and i Feel my WoRRies drift away. i will Be Fulfilled and STRONGER.

THERE ARE NO LIMITS TO WHAT I CAN ACCOMPLI I WILL PUSH MYSELF I WILL BE PROUD OF MYSELF

Birthplace: Paterson, New Jersey, NYC, USA. *Education:* Maryland Institute College of Art (MICA), Baltimore MD, USA. *Inspiration:* Paul Sahre, MF DOOM, Ed Ruscha, JD Salinger, John Bielenberg.

Although I was born in New York, my parents moved to Washington DC a few months after I was born, which is where I now live and work as a graphic designer. Both of my grandparents on my father's side are fine artists and they had me drawing and creating things at an early age. College was a great experience, and it was wonderful to be among other designers and artists in such an intensive environment. It forces you to engage, be creative and to push yourself to the next level.

I find typography really beautiful. Letters are everywhere around us and typography is language that we can all understand. I am intrigued by the notion of giving more meaning to letters that already have a sound function. The toy alphabet shown opposite, for example, was a project for my Experimental Typography class at MICA. It began as a crazy idea, but turned into something that became quite emotional. I think once I began work on the project I realized the force that the figures had. I wanted people to be able to interpret the letters in their own way. Some people thought it was cool, others really found it to be disturbing and real. I thought it was a good way to subtly present the reality of the devastation of war.

Doing editorial illustration and poster work feels like a way for me to get my artwork out to the world. It is always great to be able to make something that just 'is', with no restrictions, clients, worries or constraints. It is a great way to deal with all of the limitations that we come across as designers.

I can take my inspiration from all over the place and I particularly love seeing old signage and generic typography that is still out there. My biggest inspiration is New-York-based graphic designer and illustrator, Paul Sahre. His work is truly unbelievable; it continuously inspires and challenges me.

In my own work I try to maintain a balance between the traditional and digital. I can get a bit stir crazy when working on the computer all the time and it is just nice to get a brush pen out and really put yourself into the letterforms. I love drawing with old pens and markers, they give great texture to letters and shapes. I like to sketch and think first and then take it over to the computer as soon as I have sound ideas, although sometimes deadlines don't allow for this way of working.

I think type continues to grow and will inspire a new generation of designers and illustrators. I have been seeing a lot of three-dimensional alphabets and creative computer-generated type. I can't wait to see where it all goes next. My advice to all budding designers would be to keep your head down and your mind open.

right:
illustration Fire in the Hole
date 2006
media/techniques melted model
army figures

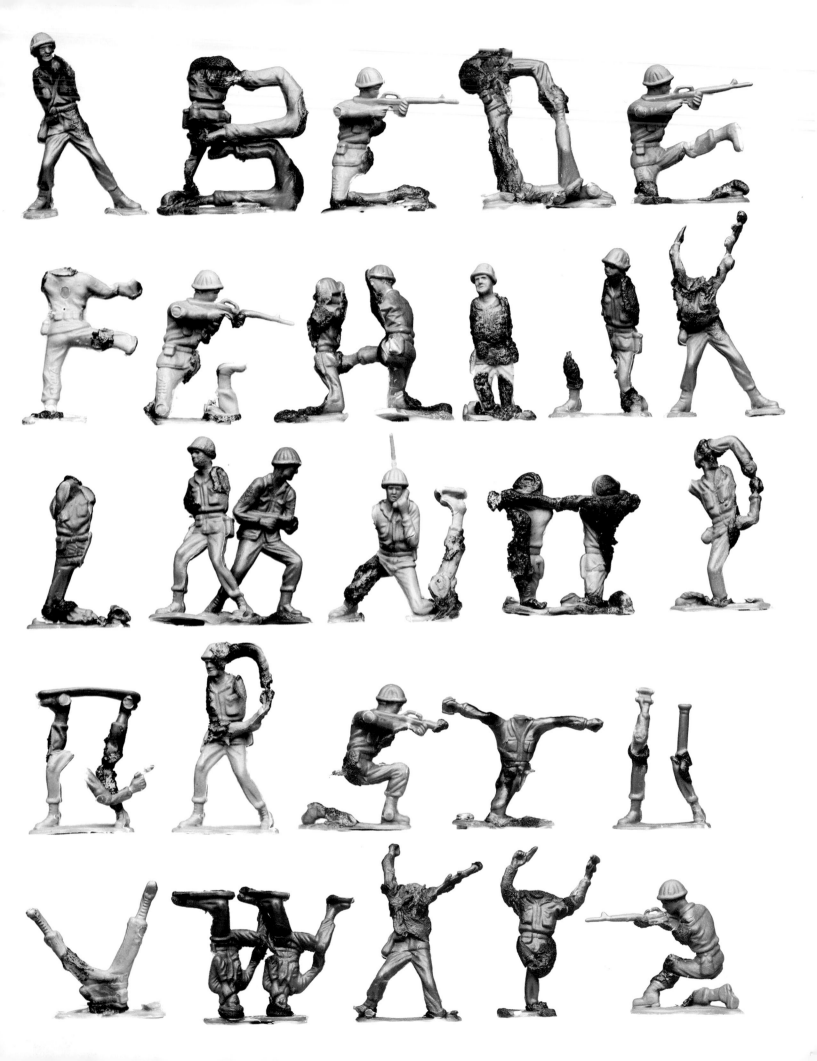

above:
illustration Concord Dawn
date 2007
media/techniques silk screen

left:
illustration New York Op-Ed
date 2008
media/techniques Adobe Illustrator
(with art direction by Brian Rea and
Guillermo Nagore)

above:
illustration Dishwasher Pete
date 2007
media/techniques silk screen

right:
illustration Hampdenfest
date 2007
media/techniques silk screen

above:
illustration Beatbots
date 2008
media/techniques Adobe Illustrator

right:
illustration MLK
date 2008
media/techniques pen and ink

104

left:
illustration Olympic Sponsor (for *New York Times* magazine)
date 2008
media/techniques Adobe Illustrator (with art direction by Julia Moburg)

right:
illustration Hopes
date 2008
media/techniques Adobe
Photoshop, Adobe Illustrator

Birthplace: Buenos Aires, Argentina. *Education:* Palermo University, Argentina. *Inspiration:* David Carson, Alex Trochut, Edward Fella, Joshua Smith, Jeremyville, Paul Insect, Jon Burgerman, Jean Spezial, Koadzn, Anders Schroder, Vince Ray, Todd Schorr, Mark Ryden, Richard May, Erkut Terliksiz, Gary Baseman, Andy Howell.

We are Carlos Serrano and Facundo Sueiro, and together we run NeoDG, a design and animation studio located in Buenos Aires, Argentina. While working together as students as part of a creative team, we soon realized that we shared the same vision about design. We believe that the most interesting thing about letterforms and type are the different emotions that can be transmitted through their form, structure and morphology. It is these elements of the design that we like to manipulate, allowing us to play and combine them with other shapes and images.

We are mostly inspired by our experiences, our emotions and our memories. Inspiration for our work can be stimulated by anything from an image or a phrase in a book to music. We also take inspiration and encouragement from other artists, particularly those listed above, because they all have their own personal vision and unique style and continually surprise us with their designs. One of the most recent influences on our own style has been the German HORT Studio. They employ a very interesting aesthetic in their combinations of fonts, abstract shapes and use of colour.

Once we have an idea, we will sketch and draw it out by hand. Then we set about seeking the elements that are required to develop the idea, whether they are images or font types. We try to create our own source and reference materials by taking photographs and making videos, creating font types, brushes and aerosol stains and anything else that might help the final design. A lot of the time the final result will differ from the original idea as we experiment and improvise during the creative process.

We use a wide variety of media, from acrylic paint, tempera and inks to aerosol, pencils and markers, on a range of different surfaces such as paper, canvas, cardboard, wood or walls. We don't have any preference for manual or digital methods. We believe that the combination of both gives the best results. We have used a mixture of software programs such as Adobe Illustrator and Photoshop, After Effects and Cinema 4D.

When we want to communicate a concept, we try to be as clear as possible about what we wish the final design to convey. Alternatively, we let ourselves just go using the inspiration that arises in the moment, making our ideas flow spontaneously.

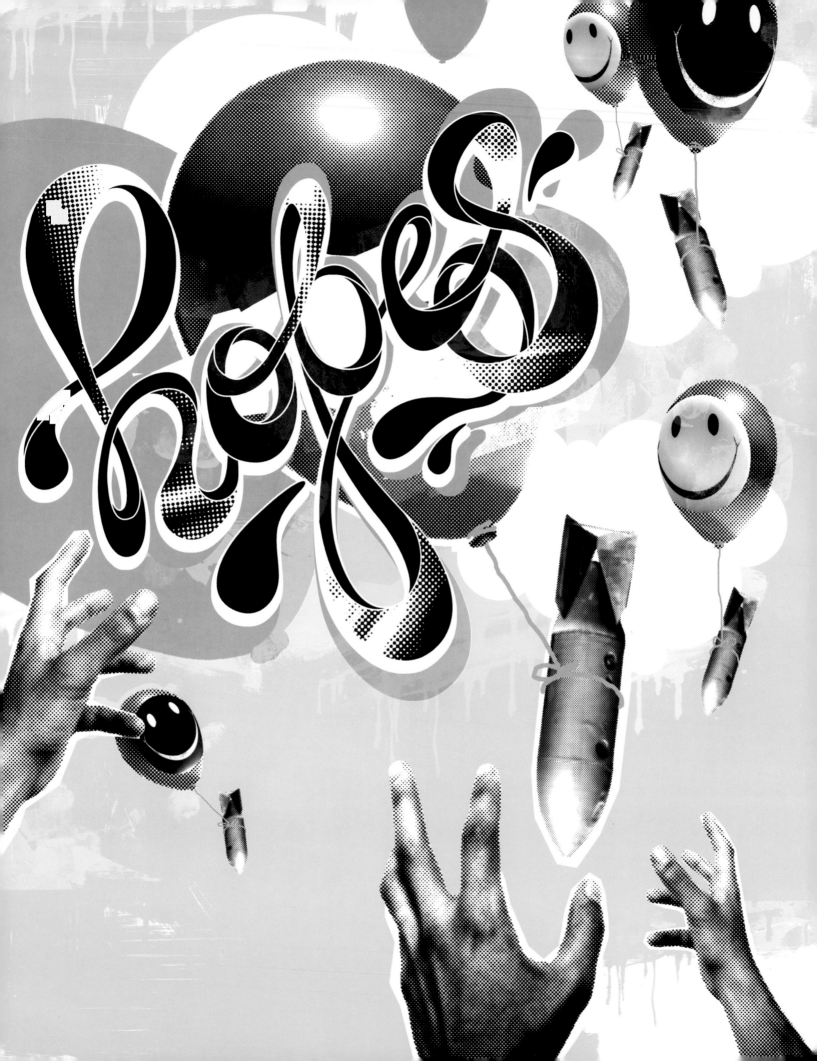

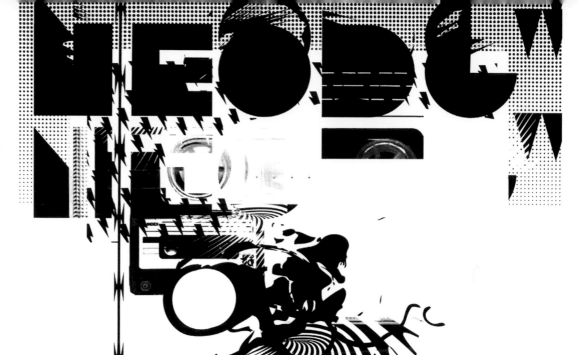

right:
illustration Remastered
date 2008
media/techniques Adobe
Photoshop, Adobe Illustrator

opposite:
illustration Motoman
date 2008
media/techniques Adobe
Photoshop, Adobe Illustrator

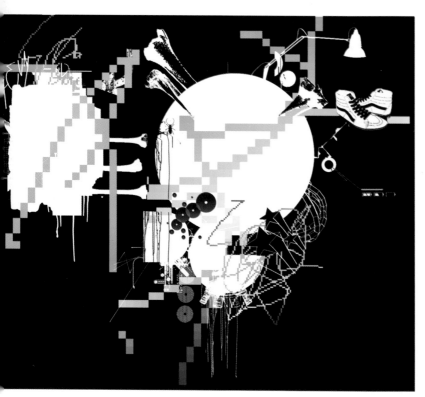

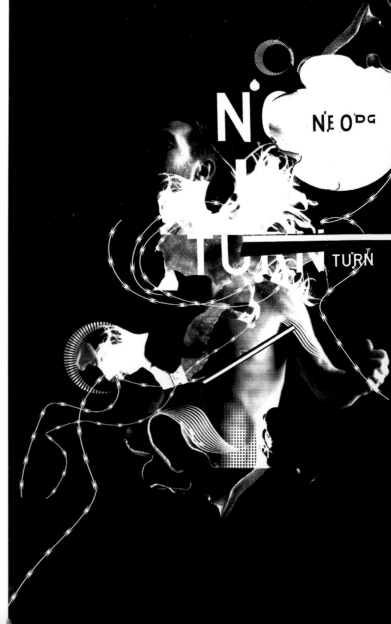

above:
illustration Jaoid
date 2008
media/techniques Adobe
Photoshop, Adobe Illustrator

right:
illustration Viejo
date 2008
media/techniques Adobe
Photoshop, Adobe Illustrator

108

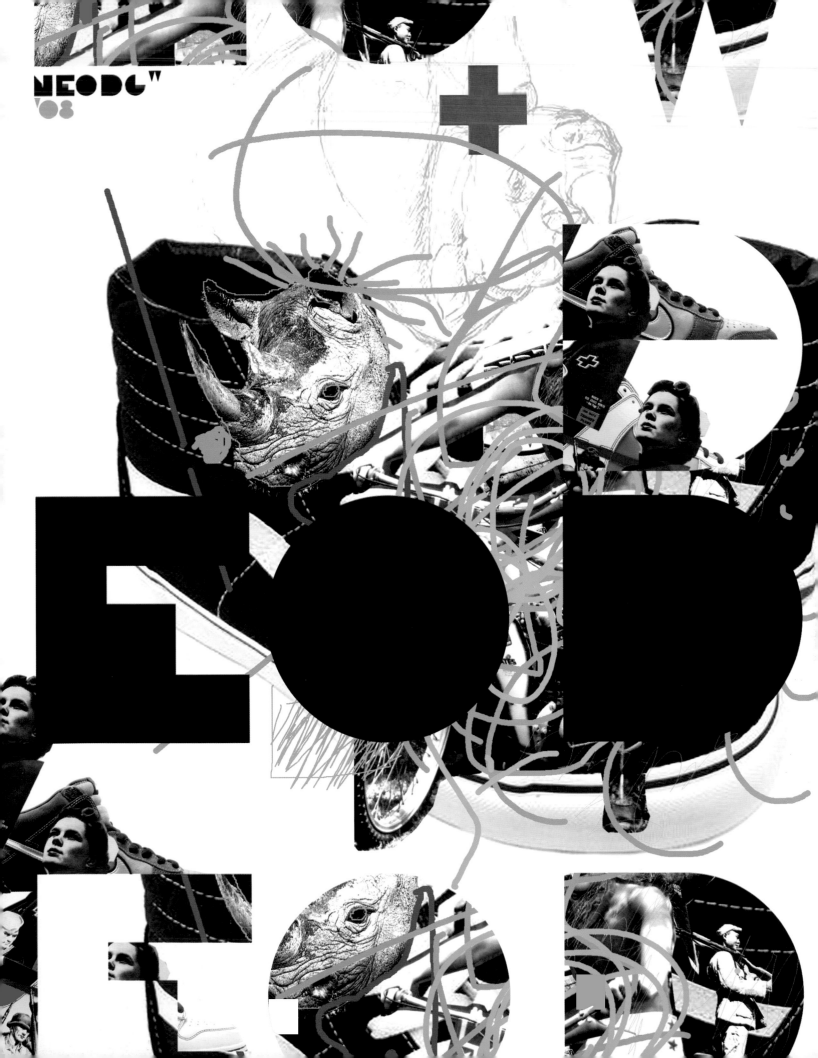

AMITIS PAHLEVAN

Birthplace: Isfahan, Iran. *Education:* California State University, Long Beach, USA. *Inspiration:* Nina Garcia, Diane Von Furstenberg, Petrula Vrontikis, Michael Osborne.

I was born and raised in Iran, in the beautiful city of Isfahan. I was always surrounded by beautiful motifs and patterns, colourful textiles and magnificent architecture. Because it wasn't socially acceptable for girls to go to art school, I studied mathematics in high school. But as much as I enjoyed working with digits and numbers, I couldn't see myself choosing this path as a career. When my family moved to southern California I seized my opportunity and studied fine arts at California State University, Long Beach, with an emphasis in graphic design. It wasn't until my last year of school that I really became interested in type and font design. Thanks to my teacher and mentor Andrew Byrom, I was introduced to the world of typography and started looking at various letterforms with a different perspective. He taught me to look for type in places that I previously never thought existed and he pushed me out of my comfort zone.

The people that have directly influenced my work in typography include Oded Ezer, with his unconventional methods of dealing with type. I also follow the work of the talented people at Non-Format, a studio based in London and Minneapolis. Other inspirations come from everything around me: people, art, film, music, food and, in particular, fashion. I use the style and colour of fabrics and textiles as an inspiration for my designs. I look all around me for inspiration since you never know when an idea will come to you; you might be having a conversation with someone, eating great food or just watching TV. Now that I live in New York, fashion has become an even more integral part of my life and a great source of inspiration.

I don't really subscribe to a preferred method of working or a media that I like to work in. I like to challenge myself and try to work with methods and materials that I have never worked with before. I like to create a problem and then solve it. I have a notebook that I carry with me everywhere and as soon as an idea sparks in my head, I make notes for myself to refer to later.

My advice to new designers would be to always believe in themselves, open their eyes to the world around them and not to be afraid of failure. I still believe I have a long way to go and so much still to learn.

right:
illustration Candle Typeface
date 2008
media/techniques photography (by Tharith Tan), wax, pipecleaners

above and right:
illustration Candle Typeface
date 2008
media/techniques photography (by
Tharith Tan), wax, pipecleaners

112

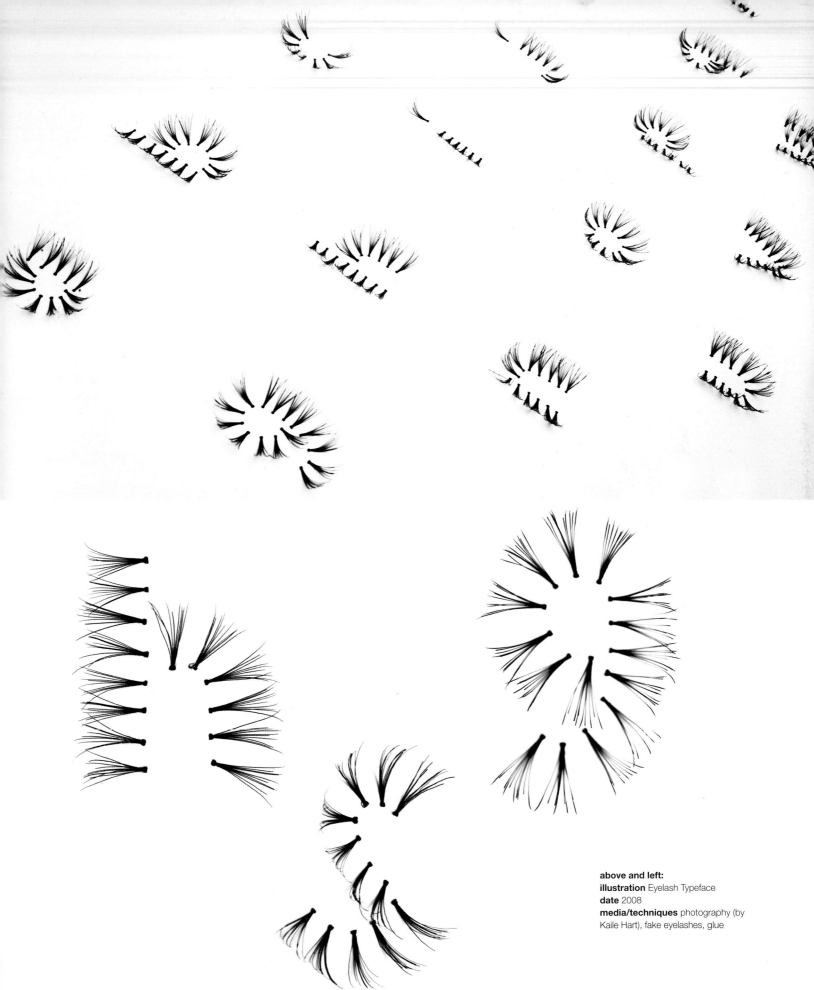

above and left:
illustration Eyelash Typeface
date 2008
media/techniques photography (by
Kaile Hart), fake eyelashes, glue

right:
illustration The End
date 2008
media/techniques Adobe
Photoshop, Adobe Illustrator

Birthplace: Los Angeles, California. *Education:* Academy of Art University, San Francisco, CA. *Inspiration:* Geoff McFetridge, Linzie Hunter, Damien Correll, Mike Perry, The Beatles, Chris Ware, Alan Fletcher, Quentin Tarantino.

When I was thirteen I received a copy of the Beatle's *Revolver* album and the music and the cover changed my life. I fell in love with illustration and design through old rock-and-roll album covers – my high school notebooks always featured crude renderings of band logos. It was a combination of this love for music and working as a layout editor on the high school newspaper that made me want to focus on a future in design.

I take my inspiration from music, city living, old animation from the 1960s and 1970s, design history books, really bad sci-fi movies or random observations and thoughts that pop into my head. The main influence on my work is the need to constantly be making or doing something artistic. Other designers and artists also influence me – looking at other people's work makes me want to get up and create. I really admire the crop of young designers who are blending together typography, illustration and design.

Now living and working in San Francisco, I usually work with pencils, pens, cut paper and collage and use vector programs like Adobe Illustrator on the computer. I don't like to get too comfortable by just relying on the computer when designing type as things can easily become too mechanical. I screenprint a lot of my work and so usually try to restrict myself to a limited colour palette, from two colours to a maximum of five.

My design process usually begins with a bunch of rough sketches and doodles, which I then edit to see what should be taken to the next level. Then it's over to the computer – scanning and tracing are also usually involved. On self-initiated projects and posters I give myself free range to explore and take my artwork to weird places.

Typography is so interesting because words and letters are such an integral part of our daily interaction with the world. I believe that there are always fresh and new ways to approach typographic design, particularly by employing more hand-drawn typography as a counter attack to the desktop publisher's millions of preloaded fonts. Unique, individual type will always provide a resistance to banality.

I think that it is very important to stay inspired and motivated and not to be afraid to make mistakes. Mistakes can only help improve finished work. My advice to those starting out would be to start with self-initiated projects and explore, explore, explore.

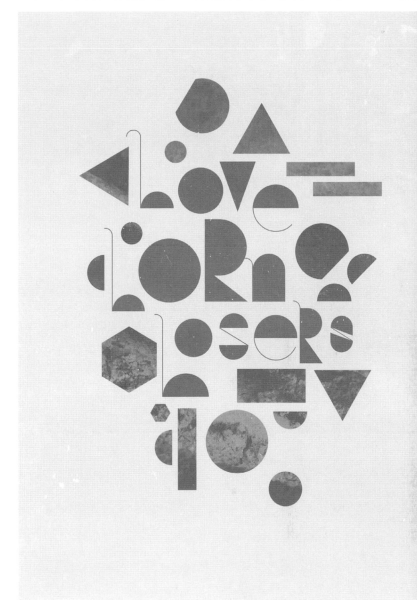

above left:
illustration Broken Down Dreamers
date 2009
media/techniques Adobe
Photoshop

above right:
illustration Love Lorn Losers
date 2009
media/techniques Adobe
Photoshop

opposite:
illustration Sound & Vision
date 2009
media/techniques Adobe Illustrator

Birthplace: Milwaukee, Wisconsin. *Education:* Milwaukee Institute of Art and Design (MIAD) Milwaukee, Wisconsin. *Inspiration:* Upnorth, Chuck Close, Robert Crumb, Herb Lubalin, Milton Glaser, Edwin H. Land, The Little Friends of Printmaking, Burlesque Design.

I've always loved to draw and create things. Growing up I was always taking things apart and rebuilding them. My childhood obsession with creating, paired with my artistic interests, got me into graphic design. As well as my day job at designscout (www.designscout.tv) I also try to maintain a steady flow of freelance and personal graphic adventures where I take the time to think a little deeper and play around. Originally I got into letterforms in high school when I was into graffiti. I also had a job where I was required to make in-store signage. These early experiences burned a letterform obsession into my head, like a third typographic eye.

I like checking out the latest artists and try to support my local art scene. I love going to a show and seeing some super-intimidating work – I like to learn from the piece by observing it and trying to figure out how it was pulled off. Hyperrealism always intrigues me – I find it interesting to see how people interpret light and texture with their brushstrokes. Inspiration sometimes presents itself when I'm out walking somewhere or am mentally idle. I just think and sort of visually brainstorm. Sometimes you'll see or hear something while thinking of a project and

it will spur a whole other branch of thought. It's always good to keep your current projects in your mind.

I find that the bulk of the design work lies with the creative fabrication of concept. Once you have a solid plan of action, actually creating the piece is easy. When I set about my work I like to do as much sketching as my timeline will allow. Sketching forces you to keep every idea and stage of your process for later review. Once I have a solid idea on paper I will generally scan it to use as reference in Adobe Illustrator. When creating, you have to remember your audience and the application of the piece; it doesn't have to restrict you whatsoever – it just makes your work more efficient.

I prefer to use markers, pencils, graph paper, Adobe Illustrator or maybe some Photoshop if necessary. My belief is that you should always start out in your sketchbook and maybe – even after taking computer breaks – dig back into your sketchbook. It's great to have both at your disposal. Technology makes producing your work even faster so that you can push it further in a much shorter period of time.

In the future, I hope that type will be treated with as much respect as it was before consumer-level computers and Microsoft Word. My advice to all new creatives is to get some thick skin and don't be afraid of re-working. The most brutal criticisms are your golden treasures, but remember that you can't please everyone.

right:
illustration Various Type Treatments
date 2006–2009
media/techniques Adobe Illustrator

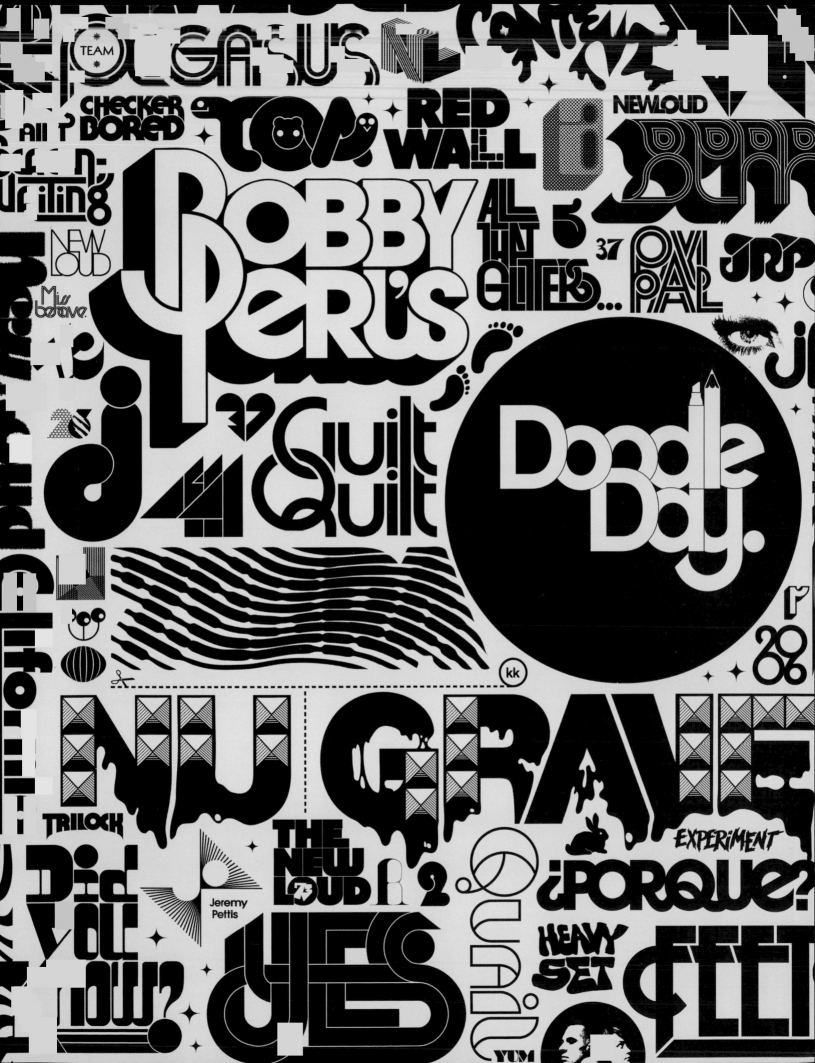

explodeo

above:
illustration Explodeo
date 2008
media/techniques Adobe Illustrator

right:
illustration Pink Cookies (for
Enstrumental Apparel Co.)
date 2008
media/techniques Adobe Illustrator

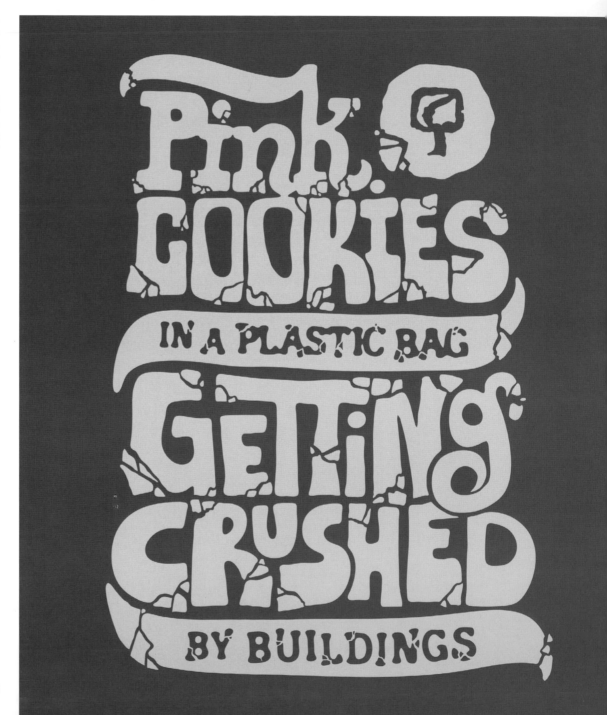

Pink Cookies in a plastic bag getting crushed by buildings

left:
illustration Get Off Your High Horse
(for Enstrumental Apparel Co.)
date 2007
media/techniques Adobe Illustrator

below:
illustration Sublurbia (for *Is Not*
magazine)
date 2008
media/techniques Adobe Illustrator

right:
illustration Tomar el Té
date 2005
media/techniques ink, Adobe
Photoshop

Birthplace: Buenos Aires, Argentina. *Education:* Buenos Aires University (UBA), Argentina. *Inspiration:* Gustav Klimt, Josef Hoffmann, Herb Lubalin, Margaret MacDonald Mackintosh, William Morris.

I graduated as a graphic designer in 1999 from Buenos Aires University (UBA) where I specialized in the design of music CD and book covers. I can remember the exact moment that I decided to study graphic design. When I was 16 a family friend who was studying graphic design showed me his project about tea. He was using the texture, bouquet, history, symbolism and aesthetics of tea to present it in a new way and I found it amazing that something as routine and ordinary as a simple infusion could become a focus for design study.

Working in graphic design and illustration, we have the opportunity to read reality – interpret it, represent it and complete it. I believe that 'a word can say more than a thousand pictures'. Just a single word can shoot out hundreds of different images, concepts, memories and ideas. A group of words (a text), or a language is even more powerful and can tell you so much about a culture.

There is a strong relationship between text and type in all my illustration work and I am inspired by an endless list of interesting artists that have also incorporated letters and text into their artistic work: Marinetti, Dubuffet, Blake, Klee, Basquiat, Lichenstein, Schwitters, Malevich, León Ferrari, Toulouse-Lautrec, El Lissitzky, Magritte and many more. I can take my inspiration from the movement of water, the sight of old iron bars or my cat sleeping, the Bodoni font, unfastened yarn, the floor tiles of a gallery, a random close up on a van Gogh, the first page of an old book, a forest in autumn, an unfortunate blot of ink – these are all things that can move me. I am also passionate about the Art Nouveau and Arts and Crafts movements. Art can be a very emotional experience. Recently I saw a beautiful exhibition about both groups in Tokyo and I felt the desire to cry for the first time in front of a piece of art. It was very emotional.

In terms of media, I use anything that I think is necessary. I prefer to start with hand drawings and will sometimes finish the work with the computer. It all depends on what I want to create. I love to use my nib pen with ink – sometimes on coated paper and sometimes uncoated. My usual working method begins with pencil sketching, inking, scanning, digital composition, printing, pencil tracing, inking, scanning, digital composition and more printing. It all depends on what effect I am looking for.

I would advise any future budding graphic designers to trust the process. I believe that illustration and design don't need genius. It is far more important that they are sensitive and thinking workers.

LAURA
VARSKY

ESTAMOS INVITADOS TÉ. La TETERA es de porce-
a tomar el TÉ. -lana. PERO no se ve*
LA TIENE frío y la
leche ABRIGARÉ, LE PON-
-dré un sobretodo mío Largo
HASTA LOS PIES * cuidado cuando beban, se
LES VA a caer la NARIZ dentro de la TAZA y Éso
NO ESTÁ * detrás de UNA TOSTADA se
BIEN escondió La
miel, La MANTECA muy Enojada La retó en INGLÉS
*. Mañana se Lo LLEVAN PRESO A UN coronel
Por pinchar a la mermelada CON UN alfiler * Parece QUE
el azúcar SIEMPRE negra fue y de un susto se
PUSO blanca TAL COMO LA VEN, *.
UN PLATO timorato SE CASÓ ANTE ay.
a su esposa La cafetera La Trata
de usted * LOS pobres coladores
TIENEN MUCHA Sed
PORQUE el agua se Les
escapa cada 2 por 3*

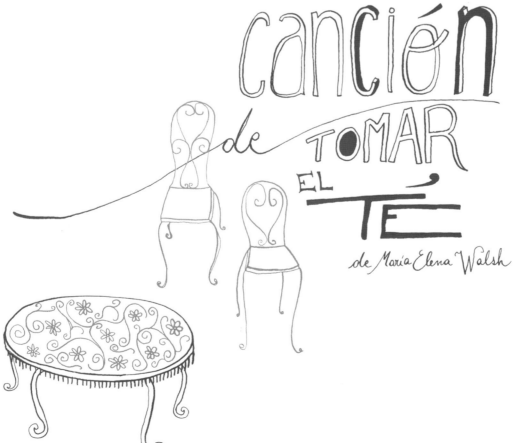

canción
de TOMAR
EL
TÉ
de María Elena Walsh

lau

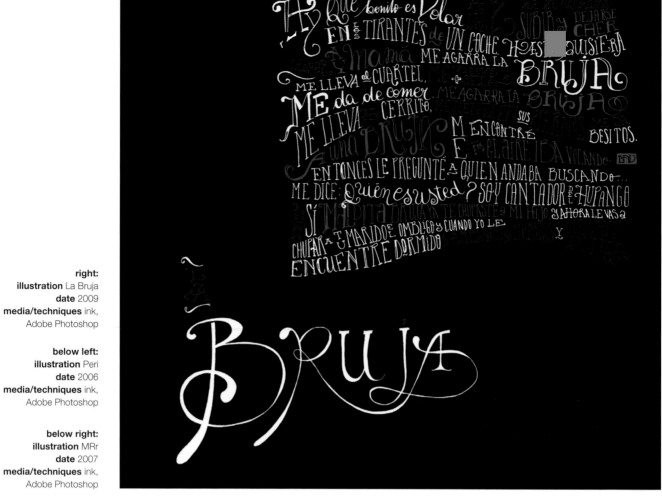

right:
illustration La Bruja
date 2009
media/techniques ink,
Adobe Photoshop

below left:
illustration Peri
date 2006
media/techniques ink,
Adobe Photoshop

below right:
illustration MRr
date 2007
media/techniques ink,
Adobe Photoshop

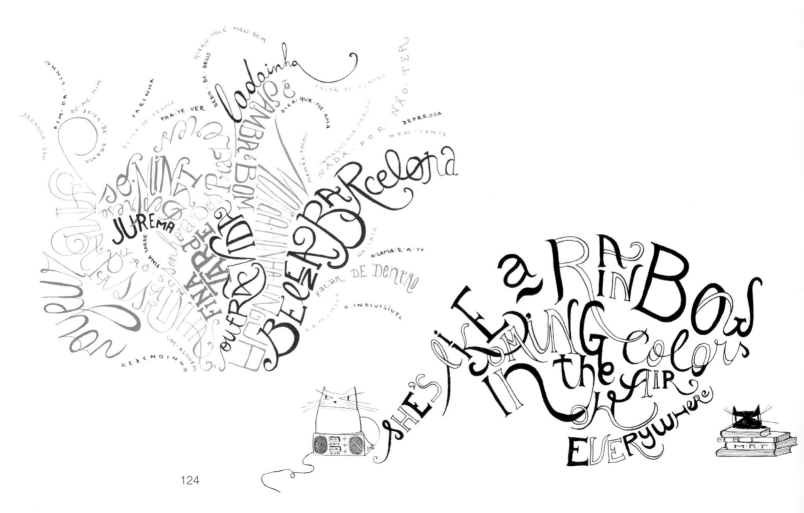

124

For 3 months (they had been married in April) they lived in a special kind of bliss. She passed the autumn in a strange love nest. It is not strange that she grew thin. She had a light attack, after that → her health never returned. Finally one afternoon she was able to go into the garden. This was the last day she was well enough to be up. To be the doctors saw a diminishing life, a life gliding away, absolutely without their knowing why. The illness never worsened during the daytime, but each morning she awakened pale as → → → death, almost in a swoon. Finally she died. The servant, when she came in afterward to strip the now empty bed, stared wonderingly for a moment at the pillow. "Sir!" she said in a low voice. "There are stains on the pillow that look like blood." The servant raised the pillow but immediately dropped it "It's very heavy" the servant whispered trembling. He ripped open the case and the ticking with a slash. In the bottom of the pillow case, among the feathers slowly moving its hairy legs, was a monstrous animal, a living, viscous ball. Night after night, this abomination had stealthily applied its to the girl's temples, sucking her blood. In 5 days, in 5 nights, the monster had drained her life away.

From "El Almohadón de Plumas" by Horacio Quiroga.

above:
illustration El Almohadón
de Plumas
date 2005
media/techniques ink,
Adobe Photoshop

NATE WILLIAMS

Birthplace: Salt Lake City, Utah USA. *Education:* University of Utah, USA. *Inspiration:* Pes, Noah Woods, Calef Brown, Louis Lambert, Dan Eldon, Graham Roumieu, Mike Bertino, Michael Slack, Gary Larson, Trey Parker and Matt Stone.

As a child I had a learning disability. When I tried to read a book my eyes would jump all over the page, which forced me to see letters as forms or objects rather than the words they represented. Now, living and working with a different language in Buenos Aires, I find myself in the same situation.

I studied sculpture at the University of Utah and worked for many years as a web designer and art director in the advertising and video game industry before becoming a full-time illustrator. After a time working in a high-tech, 3D-rendered industry I craved change. I wanted to create things that were simplified down to their essence and more organic, handmade and textured. I wanted to incorporate the human touch – accidents, mistakes and discoveries. Today, I like the contrast between mechanical and organic. There is currently a trend of using hand lettering in response to the high-tech boom of the 1990s where everything was slick and over polished. Now the pendulum seems to have swung the other way.

For me, hand rendering gives a word its tone. It tells the viewer how to interpret text on a subliminal level. It is like a horror movie with music; if you didn't have the creepy music when someone walked into the basement it just wouldn't be scary. Hand rendering is like the body language of type.

Once I receive a creative brief I contact the art director or designer to discuss the project, what work of mine they like, what we should stay away from – all to get the bigger picture of what they are trying to achieve. I brainstorm and then produce rough sketches for review. I may do a second round of sketches and will usually incorporate feedback from the client when making the final piece.

I work by combining traditional and digital methods, incorporating a variety of tools from pens, Indian ink, and silkscreen to photocopier machines and computers. Using traditional methods generates a lot of discoveries and 'happy' accidents; stuff you just can't fake with the computer. Digital lets you get rid of the 'unhappy' accidents and is efficient at automating the more tedious tasks.

Apart from having a unique style and great concepts, I think personality is key to success. Having great work is mandatory but being easy, fun and flexible to work with can give you the edge. At the end of the day, people are people and it is always nicer to work with someone that will make your job easier. Every person you work with can have a positive or negative impression of working with you – this impression is passed on like a snowball and can help or hinder you. Always value your relationships.

right:
illustration Green Marketing
date 2007
media/techniques Adobe Photoshop, Adobe Illustrator, Corel Painter

Come along on a magically mysterious tour of The Beatles' world, with poems and Beatles facts for everyone, illustrated and sung by kids, with a little help from their friends Rachael Yamagata, Marshall Crenshaw, The Bangles and Jason Lytle of Grandaddy. Roll up!

1 Magical mystery TOUR
2. Hello Goodbye
3. LOVE Me do
4. all you need is LOVE
5. good day Sunshine
6. ALL together NOW
7. I WANT to hold Your Hand
8. Birthday
9. And Your BIRD can sing
10 HERE comes the SUN
11. yellow SUBMARINE

Produced by Kevin Salem

℗&© 2008 Little Monster Music, LLC. All rights reserved. Unauthorized duplication is a violation of applicable laws. Printed in Mexico. WWW.LITTLEMONSTERRECORDS.COM

0 20286 11212 9

All Together NOW
BEATLES Stuff for Kids of all ages

A Magically Mysterious Story Book and 11 Song CD

Join the Little Monsters as they take a journey into the heart of Soul music, with poems, songs and Soul Facts for everyone, illustrated and sung by kids, with help from their grown-up friends RedRay Frazier, Tabitha Fair and Chocolate Genius. Next stop... Soulville!

SOULville
DANCING in the STREET
Everybody is a STAR
ABC
STAND BY ME
B-A-B-Y
Express yourself
MUSTANG Sally
LEAN on ME
HOW SWEET IT IS (to be loved by you)
Bonus Track
grandma's HANDS

Produced by Kevin Salem

℗&© 2008 Little Monster Music, LLC. All rights reserved. Unauthorized duplication is a violation of applicable laws. Printed in Mexico. WWW.LITTLEMONSTERRECORDS.COM

0 20286 11202 0

SOULville
Soul stuff for Kids of all AGES

top:
illustration All Together Now, Little Monster Records
date 2008
media/techniques Adobe Photoshop, Adobe Illustrator, Corel Painter

bottom:
illustration Soulville, Little Monster Records
date 2008
media/techniques Adobe Photoshop, Adobe Illustrator, Corel Painter

above:
illustration His & Hers
date 2008
media/techniques Adobe Photoshop, Adobe Illustrator, Corel Painter

left:
illustration XYZ
date 2008
media/techniques Adobe Photoshop, Adobe Illustrator, Corel Painter

JONATHON YULE

Birthplace: Ontario, Canada. *Education:* York University, Toronto, Canada. *Inspiration:* J Rocc, J Dilla, Burial, Miles Davis, Slowdive.

I remember drawing, drawing and drawing as I was growing up. I quickly discovered how to break down forms into smaller pieces to make variations. I completed a comic in 6th grade, which I reproduced with a photocopier and sold to my classmates, which was the first time I realized that I could get paid for what I love to do.

Sometimes it's hard for people to see the art in a typeface because they are used to just reading the words rather than really looking at the letters themselves, but I think there are just so many possibilities for working with text. You can work on macro and micro levels. You can go from finely adjusting the justification in a block of text through to rotating, redrawing and enlarging individual letters. You can make letters from anything but the alphabet doesn't change, keeping an amazing consistency.

I'm not sure where I get inspiration from, but there are certain designers that I respect. NORM for their wonderful typefaces and creating their own graphic world; Experimental Jet Set for their interpretation of modernism; Build for first introducing me to 'graphic design' in The Designers Republic; Nicholas Felton for being inspiringly meticulous; Lineto for their limiting but enriching typefaces; Bill Watterson for never compromising Calvin and Hobbes and Alvin Lustig for his book covers.

When creating my own work I begin with an idea and a sketch. I'll start by developing two or three different ideas and try to work from my intuition. If I get stuck, or need a good plan, then I map everything out in my mind until one idea starts to take shape. If it requires photography or illustration, I will do that as well. Then I move on to the computer where I work on everything, from touch-ups and vector illustration to the final touches on the finished layout.

I love both traditional and digital methods of working. I love drawing with a pencil, pen, brush – almost anything – but I also like the challenge of getting a bézier curve just right. Although I love my large gridded sketchbook and Mead HB 0.5mm pencil lead, I also like to work in FontLab or Illustrator. I prefer InDesign over Illustrator for working out anything involving layout. When I think about it, technology has shaped what I've done ever since I can remember. Even when I do things by hand, I'm still aware of everything that has been made possible by technology.

I would compare the future of type to the music industry – you used to have to get 'signed' to one of the big foundries but now more and more individuals are going at it on their own. The means of distribution have become much more accessible and democratized. I believe we'll see more and more independent designers and, with the popularity of software programs, we're going to see even more incredible typefaces than ever before.

right:
illustration Helbotica Fontbot
date 2005
media/techniques Adobe Illustrator

helbotica

above left:
illustration Futura Fontbot
date 2006
media/techniques Adobe Illustrator

above right:
illustration Akzidenz-Grotesk Fontbot
date 2006
media/techniques Adobe Illustrator

below:
illustration Formation Logotype
date 2009
media/techniques Adobe Illustrator

opposite:
illustration Mix CD for Samantha
date 2007
media/techniques Adobe Illustrator

Be Good (RAC Remix) — Tokyo Police Club 2:46

In The Morning — Junior Boys 4:42

Any Way You Choose To Give It — The Black Ghosts 5:19

The Art Of Letting Go — Supermayer 5:39

Sensual Seduction — Snoop Dogg 4:08

Lazy Eye (Jason Bentley Remix) — Silversun Pickups 5:50

She Wants To Move (DFA Remix) — N.E.R.D 7:41

Knife (Girl Talk Remix) — Grizzly Bear 4:42

Star Guitar — Shinichi Osawa 5:55

And I Was a Boy From School — Hot Chip 5:18

Pogo — Digitalism 3:46

Beautiful Life — Gui Boratto 8:31

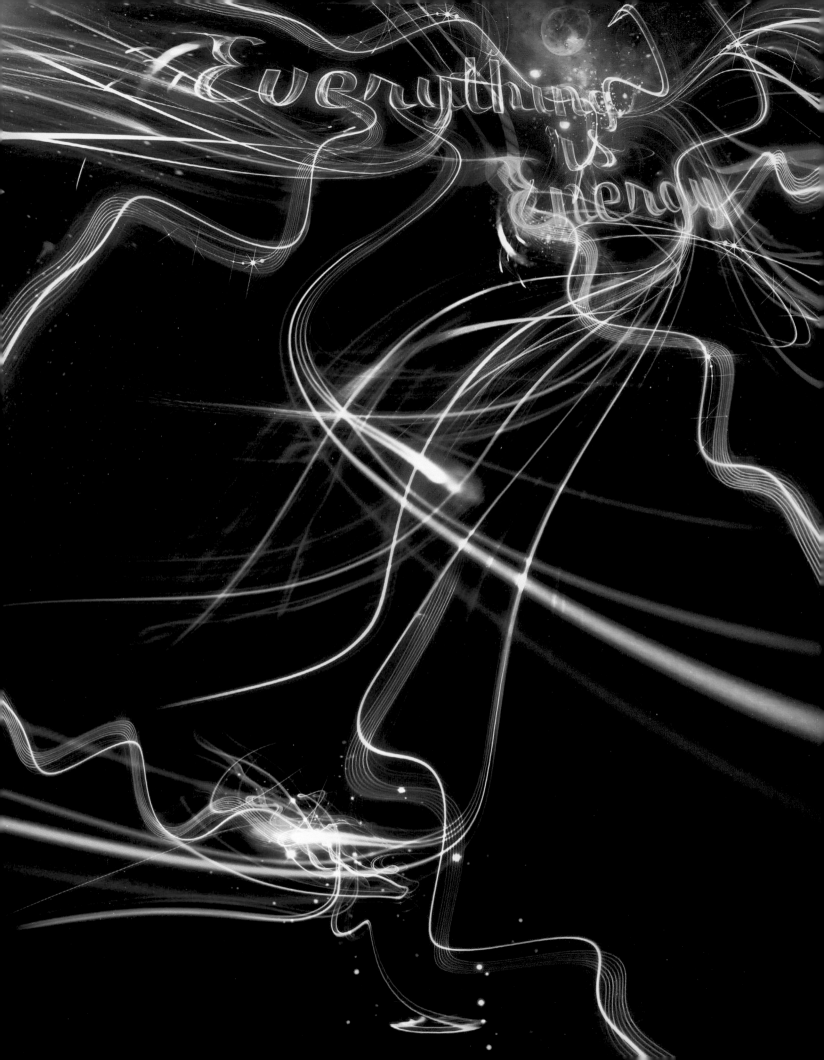

ASIA

right:
illustration New Area
date 2008
media/techniques Adobe
Photoshop, Adobe Illustrator

Birthplace: Gorontalo, Indonesia. *Inspiration:* My father, Albert Einstein, Weezer, Ludwig van Beethoven, Chuck Anderson.

I feel that there is a responsibility as a designer to make artwork that has the capability to communicate and be understood by the viewer. As an artist however, artwork is a means of self-satisfaction and self-expression. It is not important whether it is understood or not.

I believe that typographic artwork has a much heavier responsibility than pure image artwork. In most image-lead artwork, illustration assumes the main role and visual elements such as colour and composition are the main priorities. With typographic work, the emphasis is not only about selecting the correct font, deformation, colour and composition – there should be an emphasis placed on the words themselves by incorporating an emotional feeling, character or soul into the text.

I like using text and letterforms in illustration because I feel it is a more immediate means of expressing or conveying a message. Style is an important factor within my work. I have always experimented and tried to develop and establish a personal and unique style. We all know that design has its own rules but if a design is allowed to lapse away from these rules, then it will eventually become a new form or style. Such a designer will have created his own style and might even be regarded as a true artist because his artwork no longer to needs to adhere to

communication and client interest, but is instead a response to his own personal passions.

Can typography be acknowledged as true artwork? Why not? If you take a look at graffiti and street art, almost all the work sprayed onto the walls is achieved by stylizing font shapes – even to the extent that it might not be legible! These pieces have consistently appeared out on the streets as stand-alone artworks and the factor that defines them as stand-alone is the creativity of the artists to deform the font shapes into quite abstract forms.

I view the world's development in terms of design. I look at contemporary trends and try to experiment to create something new. I really believe that through plenty of experimentation we can create new styles.

Sometimes, I will build my own work from preliminary sketches and then just let my imagination flow. If I am not satisfied with the results I keep on experimenting until I get it right. I prefer working with digital applications; modern software is such a great asset to artwork exploration. We can now do things that were impossible in older days – from creating fonts and deforming letter shapes through to spoiling fonts. I particularly like using some kind of light element feature (I love to experiment with flare and light trails) as well as playing with diagonal lines within the composition.

My advice to all future designers is to keep learning, find something new and then explore it!

TONY ARIAWAN
KARTIKO

above:
illustration Book Series
date 2007
media/techniques 3D Studio MAX,
Adobe Photoshop

above:
illustration Book Series
date 2007
media/techniques 3D Studio MAX,
Adobe Photoshop

right:
illustration Typo
date 2007
media/techniques 3D Studio MAX,
Adobe Photoshop

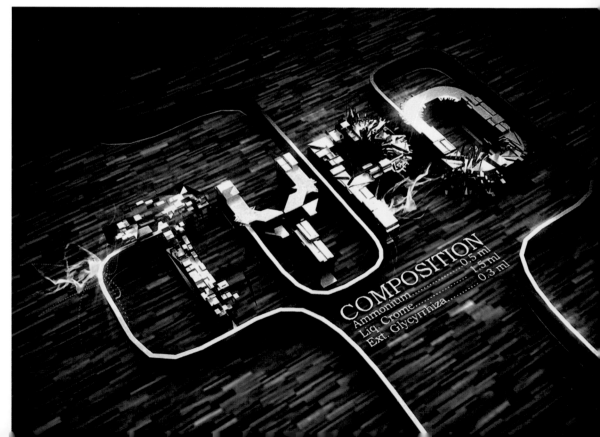

COMPOSITION
Ammonium...............0.5 ml
Liq. Crome..............1.5 ml
Ext. Glycyrrhiza.......0.3 ml

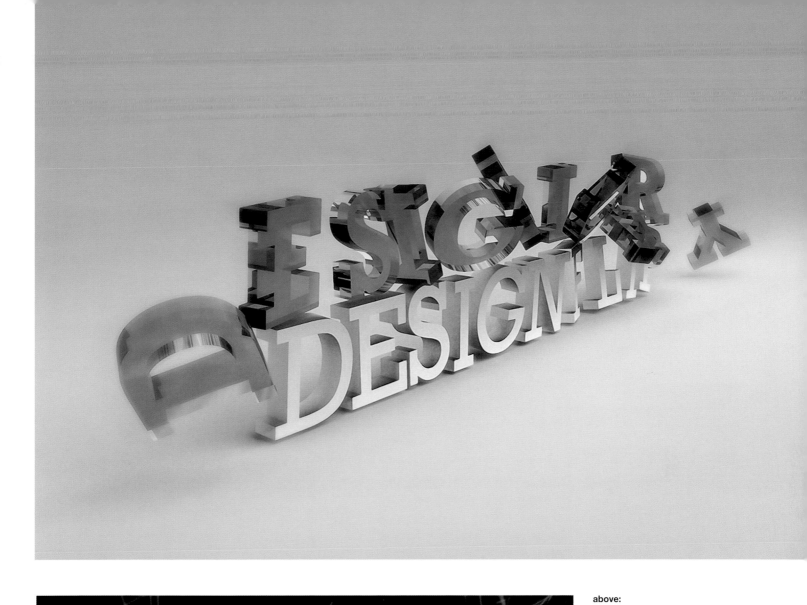

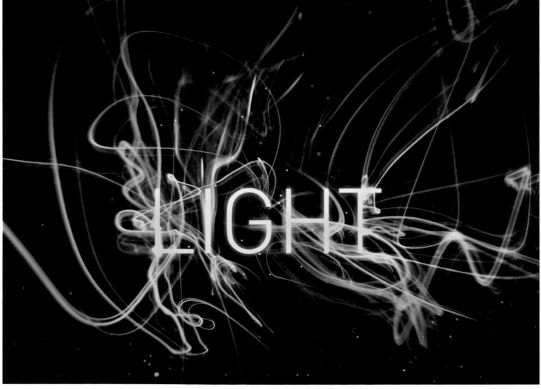

above:
illustration DDDF
date 2007
media/techniques Adobe
Photoshop, Adobe Illustrator

left:
illustration Light
date 2008
media/techniques Adobe
Photoshop

ALVIN CHAN

Birthplace: Kuching, Sarawak, Malaysia. *Education:* Curtin University, Western Australia. *Inspiration:* Peter Saville, Makoto Saito, Mevis and van Deursen, Non Format, Wolfgang Amadeus Mozart.

I was born in Borneo and when I was 14 my family migrated to Australia, which changed my life forever. I have always loved art and that helped me through the change of environment and language barriers. I studied graphic design at university and chose typography for my honours degree thesis. I discovered New Wave design and fell in love with it. The rest, as they say, is history. I now live and work in the Netherlands as a design director at Nike and have a passion for all designs with type.

I believe type is a vehicle that I can use for articulation, for both work and self expression. I love to be motivated and enjoy new experiences in life, taking my inspiration from everything around me. I surf the internet a lot and I love art, films and music. I love the work of artist Robert Rauschenberg and graphic designer Makoto Saito. Dutch design is also something very close to my heart. Recently, I am very inspired by random art, photography and the design work on internet blogs. My work is a real reflection of my personality. Because of my varied life experiences, I try to express my work in a bold, mysterious and pure way. I tend to work through an orchestrated chaos.

I think the design solution always comes from the brief and enjoy the challenge to crack it. I try to create things with an idea in mind. Some 'concepts' are clear communication solutions and some are just visual ideas. I always start work with mood boards and, sometimes, mind mapping. Then I visualize these ideas as artistic concepts and develop them into final designs. This might be by myself or with the collaboration of others working in creative disciplines, such as photographers, illustrators and designers. I predominantly create designs digitally but enjoy mixing the mediums of traditional and digital.

Type, like fashion, tries to overturn itself: from the Baroqueness of New Wave to the neutrality of Helvetica; then from the neutrality back to personality with the handmade.

It is always important to learn about yourself and how you create. My advice is to pick up as many skills as possible and always stay hungry. Most of all, have fun and enjoy the ride.

right:
illustration Man & God
date 2007
media/techniques Adobe Illustrator

GUD

MAN

MAN

E

GOD

god created man in his own image. genesis 1:27

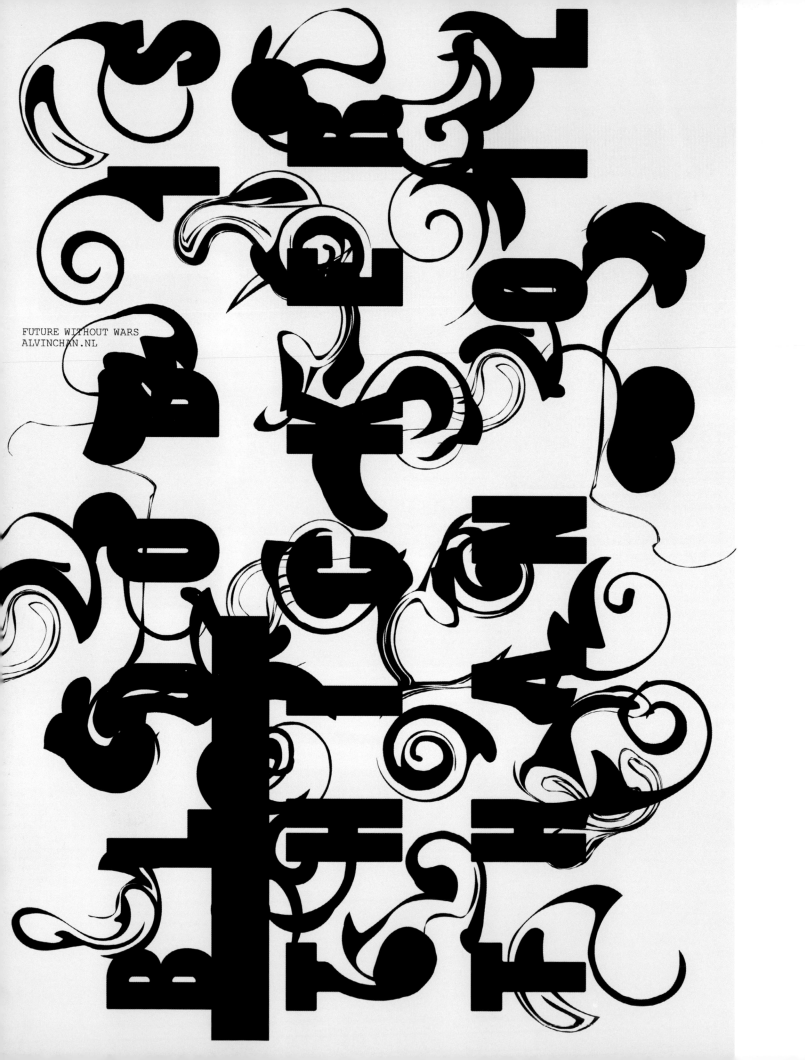

FUTURE WITHOUT WARS
ALVINCHAN.NL

opposite:
illustration Blood Is Thicker Than Oil
date 2007
media/techniques Adobe Illustrator

left:
illustration AIR Type
date 2006
media/techniques Adobe Illustrator

below:
illustration AIR Type Studies
date 2006
media/techniques Adobe Illustrator

Birthplace: Chilgok-gun, Gyeongbuk, Korea.
Education: Kookmin University, Seoul, Korea.
Inspiration: Robert Massin, Honoré Daumier,
Chris Ware, Nick Dewar, Eduardo Recife.

I was born in a small town in Korea. As a child, I sold my pictures to my friends and from that time onwards I decided to be an illustrator. Later I moved to Seoul to study graphic design, where my professor, Jea Hyuck Seong, gave me a real appreciation of the form. I remain very much influenced by his attitude and passion for graphic design.

I now love to work with type. Although I prefer to think of myself as an illustrator, I enjoy typography and graphic design very much – so much so that I always want to mix them all together. After reading Robert Massin's *Letter and Image* I became completely hooked on illustrative type. I discovered that, although there are many illustrative types, there is not usually any interaction between the letters. I believe that words are a montage of each letter it contains and the montage in a picture shows the full story. So I like to make fonts that make up random stories when they are written.

I also believe that posters can have a typographical hierarchy. My poster design, shown opposite, was my first artwork to mix both letters and image together. Each letter shows the gradual change from letters to image, expressed as analog to digital.

Before I start a project I always make a simple plan to generate my concepts and ideas. My preferred process of creating work is through self-referencing. Previously I always referred to the works of other artists and designers because I wanted to be like them – influences included Honoré Daumier, Chris Ware, Nick Dewar, Robert Massin and Eduardo Recife. However, I have now determined to refer instead to 'myself' – to 'be myself' – and I continue to reference my earlier works in my new designs. Most of my pieces now have a continuity that I like. I prefer to execute my designs through the computer and its software such as Adobe Photoshop or Illustrator.

My advice to all new graphic designers and artists is not to set out to make a masterpiece – just enjoy what you are doing and keep on creating and producing.

HWAN UK
CHOE

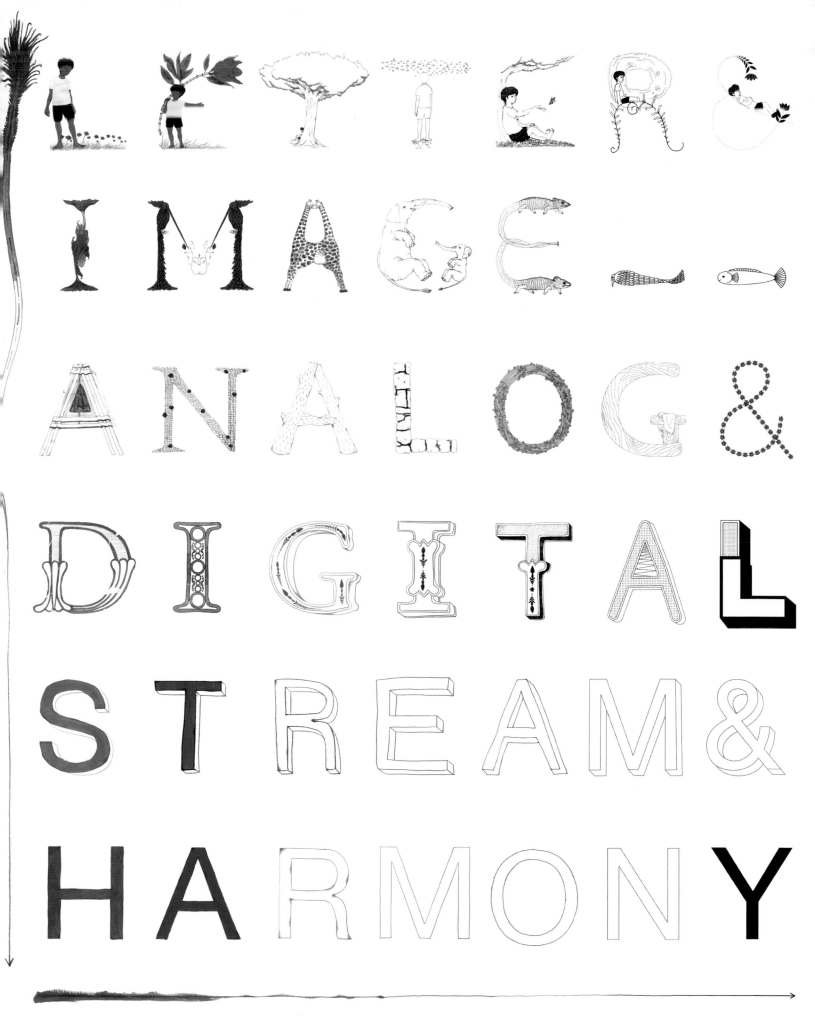

LETTERS
IMAGE-_-
ANALOG&
DIGITAL
STREAM&
HARMONY

above:
illustration Accidental Postcard 1
date 2008
media/techniques Adobe Illustrator

above:
illustration Accidental Postcard 2
date 2008
media/techniques Adobe Illustrator

above:
illustration Nature
date 2008
media/techniques cut paper

left:
illustration This City Was Never Here
date 2009
media/techniques steam on mirror

147

LUCA IONESCU

Birthplace: Bucharest, Romania. *Education:* Design Center Enmore, Sydney Institute TAFE, Sydney, Australia. *Inspiration:* Tom Carnese, Herb Lubalin, Saul Bass, Massimo Vignelli, Yusaku Kamekura, Michael C. Place, Ben Drury, Dmote, Mode 2, Alex Trochut, Aaron Horkey.

I grew up in Bucharest until the age of nine. My family migrated to Australia in 1988 and I have lived and worked in Sydney ever since. My mother worked as a draughtsperson in an architecture firm and my grandmother was an artist. I still remember her doing sketches for me to colour in. I have been drawing since a young age. I never seemed to put pencil or pen down and was always doodling and drawing over all my possessions. At high school a design and technology course paved the way to Enmore where I studied design.

I am quite obsessive about typefaces. On my typographic journey I have amassed a large collection of old type specimen catalogues, logo books, old newspapers, advertisements, music sheets and posters, all of which have interesting lettering. I love seeing the many variations of a typeface and how it has been interpreted by different designers and artists.

Producing logos and trademarks allows me to explore my passion for type. Creating iconography can be quite a rewarding process, crafting meaning into a single icon. The other thing I love about lettering and typography is that it can either be illustrative or understated and that

allows me to keep challenging my own ability to experiment with type.

When working on a project I sometimes like to craft type by hand, sketching out ideas, scanning them in and finishing the work in Adobe Illustrator, Photoshop, 3D or, at times, a combination of all the applications. Recently I have been exploring a lot of traditional media such as hand lettering. The more skills I learn, the better I can execute my ideas and so I have more to offer my clients.

I place great importance in taking time out to create experimental typography and lettering. I take my inspiration from my surroundings and my life experience. Music, film and fashion are all-important to a designer as they can influence mood and subconsciously alter designs. I enjoy taking photography trips, shooting old signage and antique objects.

I am looking forward to the future of type and typography. The thing that fascinates me most of all is the influence technology will have on the typography of the future. My generation grew up with Atari 2600's and Space Invader machines with – until the late 1990s – limited access to the internet. The next generation has been growing up with quad core processors, Play Stations and constant access to the overabundance of information on the internet. With current advances in technology, the next generation of typographers will make us wonder how we ever managed to produce anything before.

right:
illustration Love Embrace
date 2009
media/techniques pencil, Cinema
4DXL, Adobe Photoshop

above:
illustration Sound Bites
date 2007
media/techniques pencil, Adobe
Illustrator

right:
illustration Olde Fashioned
date 2008
media/techniques pencil, Cinema
4DXL, Adobe Photoshop, Adobe
Illustrator

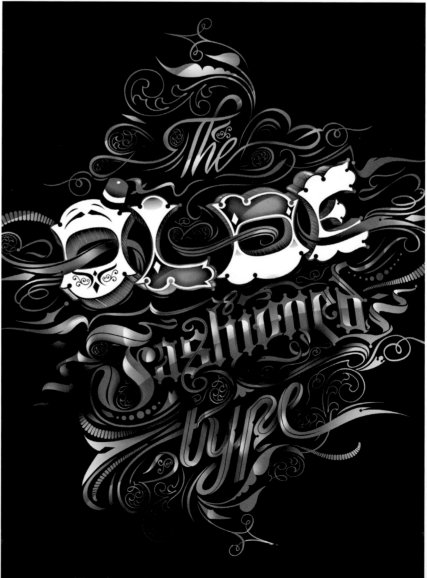

above:
illustration Akin
date 2008
media/techniques pencil,
Adobe Illustrator

left:
illustration One Soul
date 2008
media/techniques pencil,
Adobe Photoshop

right:
illustration Gettin' Loose – Some
Type of Wonderful
date 2008
media/techniques pencil, Adobe
Photoshop, Adobe Illustrator

Birthplace: Melbourne, Australia. *Education:* Melbourne School of Art, Melbourne, Australia. *Inspiration:* Herb Lubalin, Parra, Pablo Ferro, Saul Bass, Jim Phillips, Alex Trochut, Gary Taxali.

I have been interested in design, illustration and typography for as long as I can remember. During the 1980s I was a keen skater and everything I did revolved around skateboarding and it's associated culture, which is where my interest in design, illustration and typography stemmed from. Skate graphic illustrators like Jim Phillips and Vernon Coutlandt Johnson were as much my idols as Ray Barbee, Tony Hawk and Christian Hosoi. I was obsessed with skate magazines – even the ads inspired me. Having always been interested in magazines and publications, I began to recognize that the typeface in a layout or design is one of the most important elements on the page.

In the mid-1990s, while still a student, my friends and I started a publication that became quite successful. It became our full-time job, allowed us to travel the world and introduced us to the business of design and publications. In the late 1990s we teamed up with another friend and started a new business called Lifelounge. Lifelounge has since taken on many forms over the years but the fundamental value that all of us possess is the desire to create the kinds of things that people similar to ourselves can be entertained or inspired by. Originally, Lifelounge was a website set up to be a news source on everything that was happening in the world of snowboarding, skateboarding, inline, surfing, BMX, music and fashion. The business began to branch out into client services, offering design, marketing and advertising to companies that wanted to communicate with the same people we were already talking to.

From our work with Lifelounge I believe that the type associated with a product is as much part of the brand as it's logo, choice of colours and overall design. For a brand to be successful, all of the elements that represent it need to be coming from the same place, expressing the same tone and communicating in the same language, both literally and emotionally.

There has been a great resurgence in the appreciation of typography over the last few years. There's been a return to detail and it's refreshing to see so many people combining a variety of styles and techniques and pushing the boundaries. I think our ability to be connected and inspired by people all over the world will continue to drive creativity, technique and design in a positive direction. Witnessing the decline in print media and rise of the internet, the value of animated type will become increasingly prominent. However, I think the fundamentals and building blocks of the craft will remain – we'll just be able to take our ideas and creativity a lot further.

LUKE LUCAS

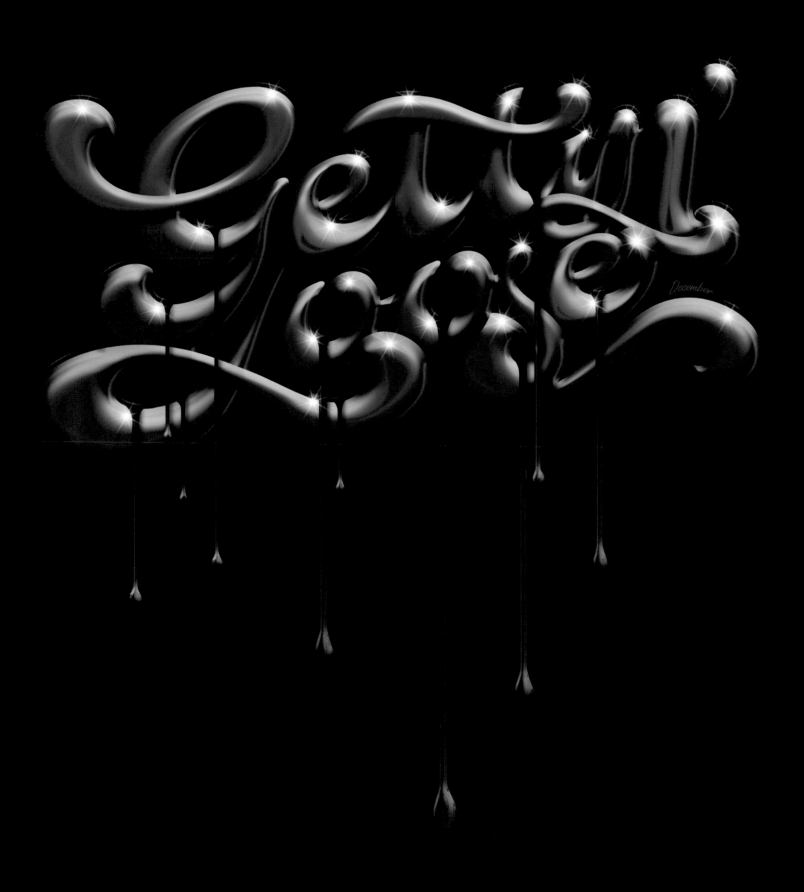

See how they LIVE!
See how they LOVE!

above:
illustration Swing City (for *Lifelounge Magazine*, The Dirty Edition)
date 2008
media/techniques Adobe Photoshop, Adobe Illustrator

right:
illustration PLEIX Title Treatment (for *Lifelounge Magazine*, The Tiny Edition)
date 2007
media/techniques Adobe Photoshop, Adobe Illustrator

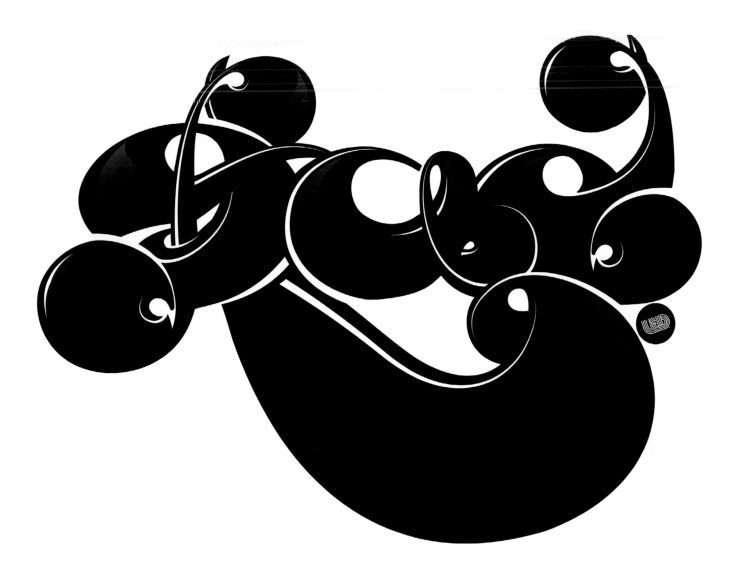

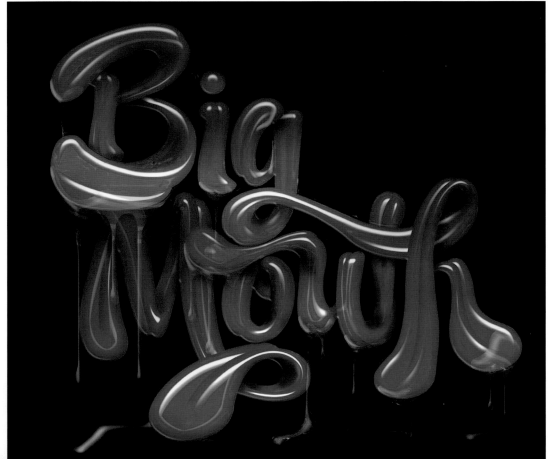

above:
illustration Rad
date 2009
media/techniques Adobe Illustrator

left:
illustration Big Mouth Project ID –
Drool Treatment
date 2009
media/techniques Adobe
Photoshop, Adobe Illustrator

155

KUM-JUN PARK

Birthplace: Haenam, Republic of Korea.
Education: Hong-ik University, Seoul, Korea.
Inspiration: Bruno Munari, Le Corbusier, Paul
Rand, Jan Tschichold, Wassily Kandinsky, my
colleagues, my mother.

During high school I became interested in art. I studied design concepts and theories through books before going onto Hong-ik University. The time I spent there set the cornerstone for my design mind and since then, design is everything in my life. I now work and live in the very busy city of Seoul as the creative director of 601Bisang, a conceptual and experimental design studio that I founded 11 years ago. We design for our own brand 601STREET and 601Bisang Publications as well as for multinational corporations such as Samsung, LG and Amore Pacific. We organize various projects including the 601Artbook.

I personally like to work in books and posters. A poster challenges the designer as it needs to show everything in one place. A book needs to have timely structures, such as storytelling, which makes it a challenging and interesting medium. Whatever the medium, I aim to create unique combinations of types by deconstructing and reconstructing typography.

I work mainly with digital tools but I start by experimenting with tangible media. I choose the paper carefully and make expressive marks using sprays, calligraphy and other materials – sometimes even trash from the rubbish bin can be a good source. I borrow digital technology to introduce my artwork to the world, but the process and humanity at the core of my work remains analogue.

I approach each project from its own communicational requirements, which means that I don't work with a particular style in mind. I try to be careful not to stray too far from the question 'why?' because I believe this essence is more important than decorative features on the outside. Storytelling is vital to my working method. I decide on the story that will be carried from the beginning to the end, and how that theme will be represented as an image.

I used to take inspiration from other artists and designers, journeys, or cultural shocks but as I get older, I find I discover new dimensions in more trivial, everyday stuff. The symbols I read in daily life convey people's traces and stories. I wander about markets or mountains to collect motifs. In my spare time I enjoy experimenting by digitizing my visual sources, which may shake the original concept or require everything to be re-done from the beginning. I am always willing to work open-ended and accept anything new until the artwork is finished.

It seems that anyone can work with type these days. We are surrounded by abundance of types but its development and progression has slowed down. Through this popularization of type we will see the evolution of types based on legibility and originality where the role of designers will be more important than ever.

right:
illustration Bless China
date 2008
media/techniques Adobe
Photoshop, Adobe Illustrator,
Quark Express

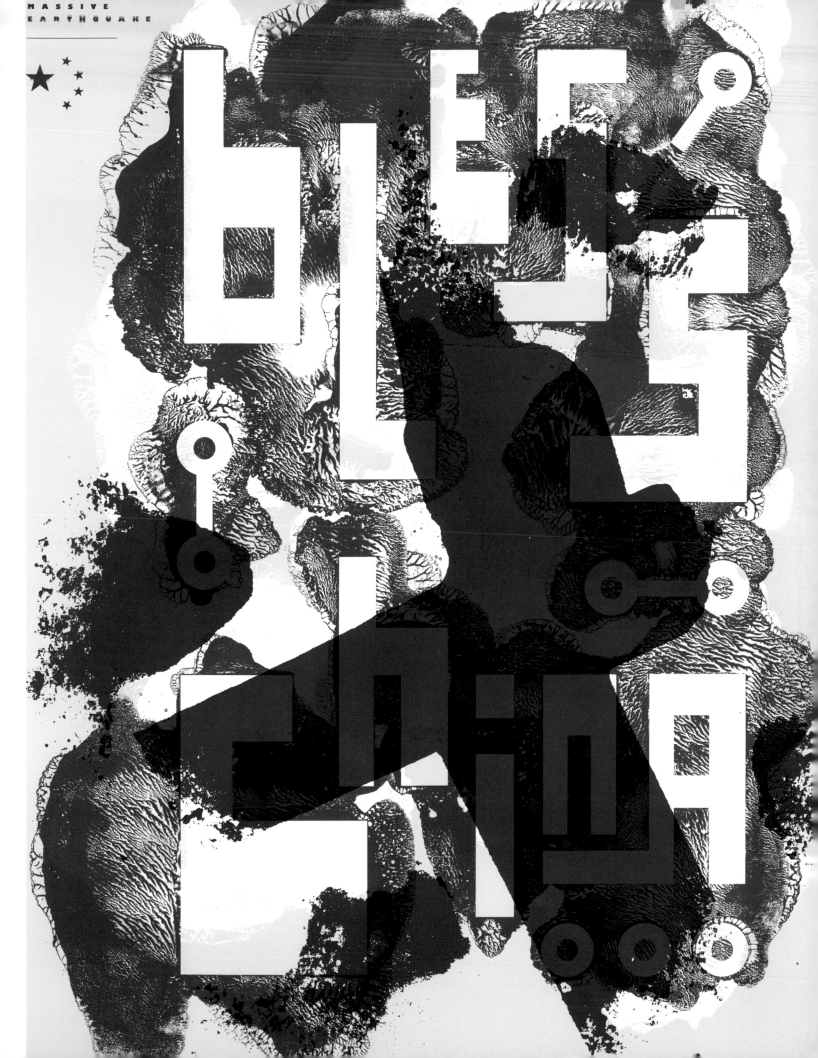

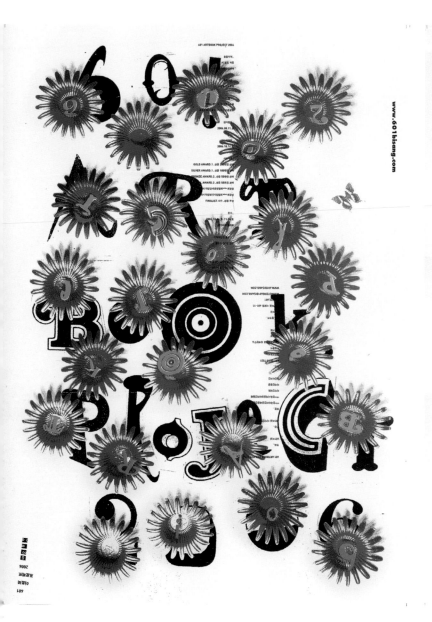

above:
illustration 601Artbook Project
date 2006
media/techniques Adobe
Photoshop, Adobe Illustrator,
Quark Express

158

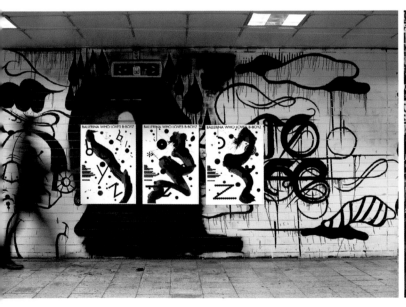
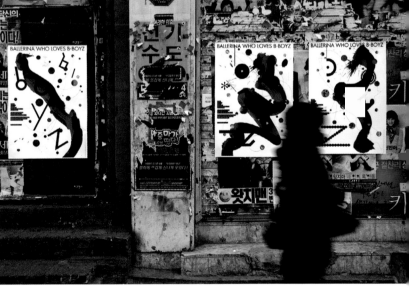

top:
illustration The 10th Anniversary of 601Bisang – '3i'
date 2008
media/techniques Adobe Photoshop, Adobe Illustrator, Quark Express

above:
illustration Ballerina Who Loves B-Boyz
date 2008
media/techniques Adobe Photoshop, Adobe Illustrator, Quark Express

Birthplace: Seoul, South Korea. *Education:* Kookmin University, Seoul, Korea. *Inspiration:* music, movies and fashion, 1960s, 1970s and 1980s culture.

I was born in Seoul but soon moved to South America (Costa Rica, Colombia and Brazil) and lived in 13 different places and studied in eight different schools before returning home to Korea to study visual communication design at Kookmin University. By living in such diverse countries I've acquired many languages, such as Korean, English, Spanish and Portuguese, and it is through my travel experience that I have been influenced by their diverse cultures. This is probably why I like vintage, elegant, chaotic, and minimal design all at the same time. I love to mix different styles together and I would say that I get all my inspiration from Seoul itself. Seoul is a chaotic, disorganized city. The graphics we see here are terrible but I find them quite attractive and interesting.

I had my first computer when I was 13. At that time, HTML and Photoshop were the biggest issues in the Korean web community, and I was able to be part of that group. I enjoyed creating really beautiful things with the computer. One day, a person asked me to make some GIFs I was working on, and told me she would pay me 500 won (50 US cents) for each. I made 5000 won in total. It was the first time that I had earned money without the help of others. It was also my first experience as a designer of dealing with a client and from that point onwards I have always enjoyed designing for others. Because I am not just limited to the Roman alphabet, but also have experience of Korean, Japanese and Chinese characters, I am interested in the decorative forms and structures of lettering rather than seeing and using them purely as a means of communication. I love to work with sporadic designs, developing ideas that come to mind like a flash of light. However, I have to admit that this doesn't happen too often. So I search for similar work that can guide me to my final destination. Seeing lots of other people's work is a great help for me. I get different or even better ideas from these. When an idea is set, it doesn't matter what media is used to achieve the result. I use whatever is appropriate for each project, whether it's digital or analog.

The only restriction I place on myself when working is how much to allow my own style to influence a project. Often, I have to manufacture a balance between what I like and what the client wants, and that can be very hard. I don't want to lose my own identity and make the work look like somebody else has created it, but at the same time, I want to satisfy the client. My advice to all future designers is to keep on experimenting and never hesitate by thinking that someone else has probably already done it. Nothing is new, so just go ahead and do it.

right:
illustration Halphabet
date 2009
media/techniques Adobe Illustrator

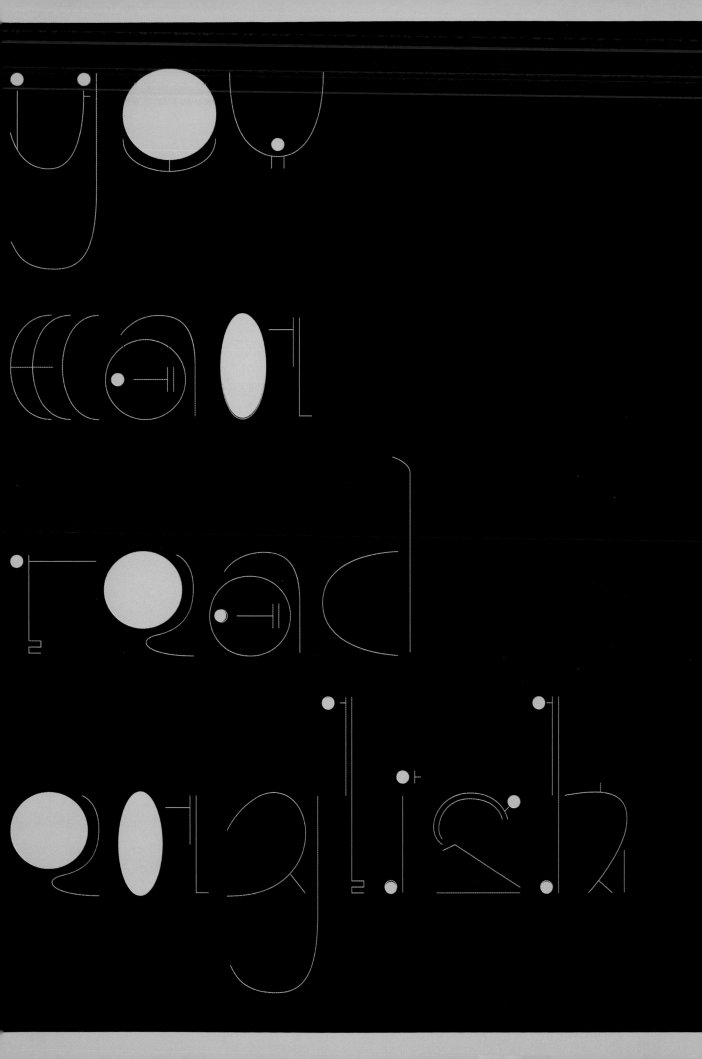

you can't read english

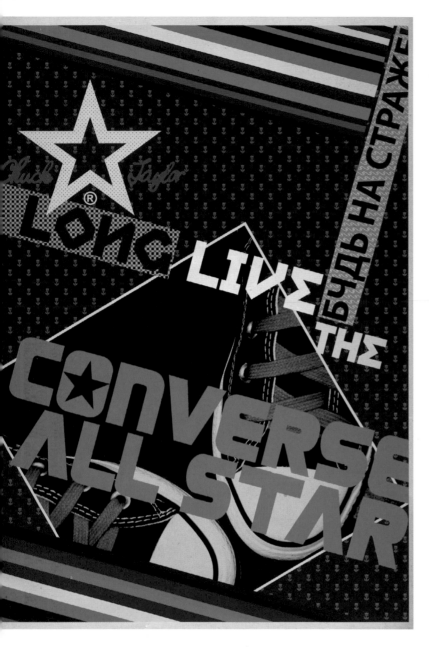

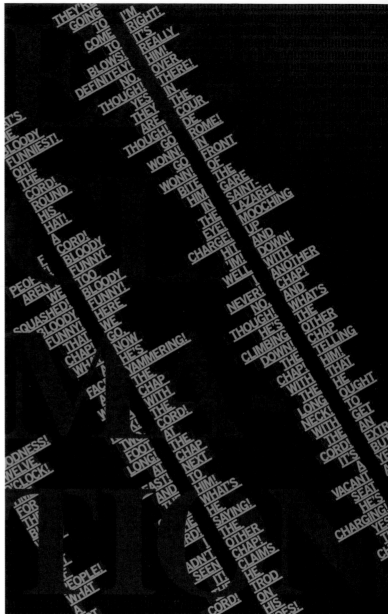

above left:
illustration Romantic Constructivism
date 2007
media/techniques Adobe Illustrator

above right:
illustration Exclamations
date 2007
media/techniques Adobe Illustrator

opposite:
illustration Pattern and Typography
date 2008
media/techniques Adobe Illustrator

pattern (plural patterns)
that from which a copy is made
design, motif or decoration formed from multiple copies of an original fitted together
arrangement of objects, facts etc. which has a mathematical, geometric, statistical etc. relationship
a series of steps, repeated
the quality held in common by a pattern
(linguistics) in semitic and other afro-asiatic languages, the arrangement of prefixes, suffixes,
consonant-doubling, vowels, and stress in a word formed around a consonantal root

typography (uncountable)
the art and technique of type design, and arranging and formatting text

pattern (plural patterns)
design, motif or decoration formed from multiple copies of an original fitted together
arrangement of objects, facts etc. which has a mathematical, geometric, statistical etc. relationship
a series of steps, repeated
(linguistics) in semitic and other afro-asiatic languages, the arrangement of prefixes, suffixes,
consonant-doubling, vowels, and stress in a word formed around a consonantal root

typography (uncountable)
the art and technique of type design, and arranging and formatting text

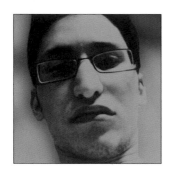

right:
illustration I Hate CMYK,
I Love RGB!
date 2009
media/techniques Adobe
Photoshop

Birthplace: Tehran, Iran. *Education:* Gorgan Natural Resources University, Golestan, Iran. *Inspiration:* Bahram Beyzaei, Mehdi Akhavan Sales, Mostafa Mastour, Reza Abedini.

I became interested in art when my older brother gave me a comic book and encouraged me to draw using oil pastels. I became totally hooked and started drawing caricatures, mostly copied from Iranian masters such as Nikahang Kowsar and Mana Neyestani. I was attracted to graphic design as a means of expression and later on started to use computer software to enhance my rough sketches and drawings. I have always loved experimenting with new fonts and typefaces and integrated these into my posters and logo designs.

As a result of my diploma in mathematics and physics and degree in surveying, I have always valued typography and typefaces far more than images and pictures. I believe that, when done successfully, typography transcends its craft and becomes true art.

I take my inspiration from all forms of art and I admire the Iranian New Age designers because of their courage and audacity. They have a new approach to working with traditional values and don't necessary obey the rules. I am interested in aspects of irony and satire and attempt to embed these elements within my work. I enjoy incorporating indirect ways to communicate the message in my work.

I usually start out with a theme or slogan that I want to use. After deciding upon its message, I explore the concept by sketching out possible ideas. When I am happy with my plans I then illustrate the design on a computer. I consider myself to be a creative individualist – a new-age avant-garde designer that doesn't accept old things and wants to experience change.

I am particularly interested in the differences between Persian Script and Arabic and like to change the formation and appearance of text. Because of this I decided to design a series of Persian fonts with new and unique features. As a typographer I have created over 30 individual typefaces by looking to my own culture for inspiration, including Iranian motifs and Persian lettering as well as traditional and historical objects. I designed the first Dirty font family in Iran (called ShahabSiavashMIXEDfont) and also devised my own method of handwriting with pen that I call KAJIRE, which is based on the Moala calligraphy of Hamid Ajami.

I believe that there is a movement to change Persian type and script that will develop in new ways over the next few years. I have already designed my own typeface that alters the Persian alphabet to use single letters instead of the usual four-formation letters in our language. It is all about forgetting the previous rules and regulations and having the courage to create new things.

SHAHAB
SIAVASH

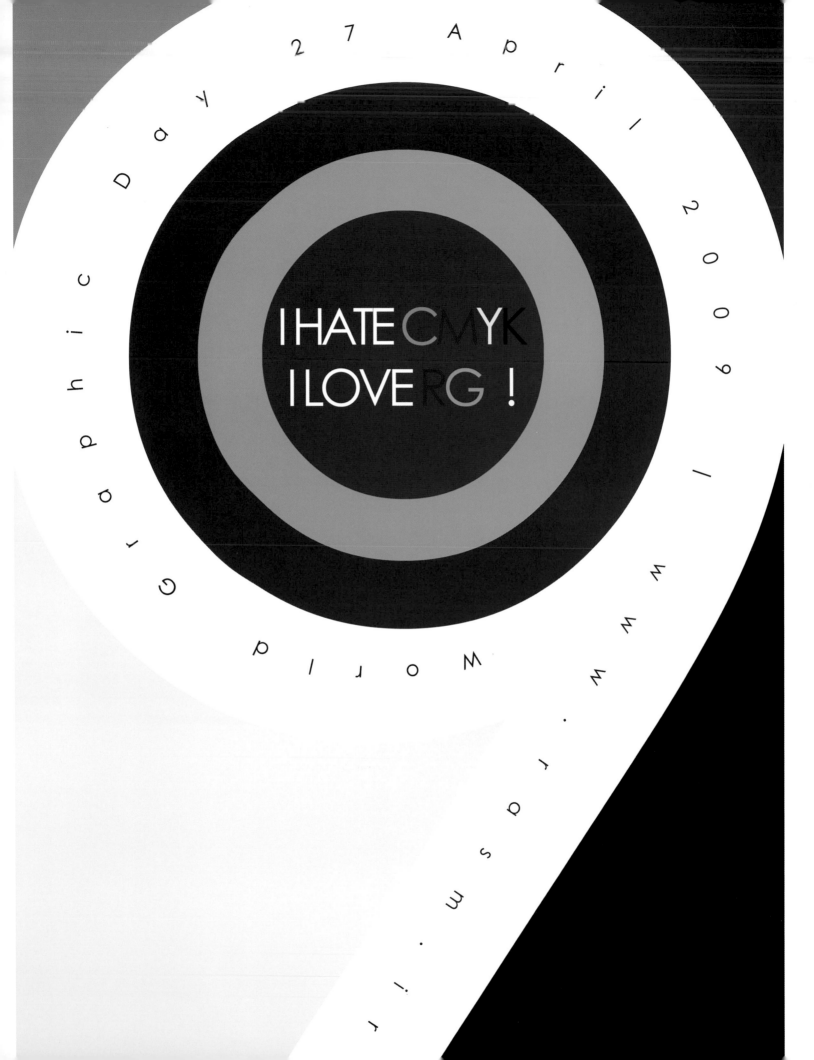

I HATE CMYK
I LOVE RG !

Graphic Day 27 April 2009

World Graphic Day

www.irdsm.ir

above left:
illustration Armenian Typography
date 2007
media/techniques Adobe
Photoshop

above right:
illustration Mowlana
date 2007
media/techniques Adobe
Photoshop

opposite:
illustration Decay
date 2007
media/techniques Adobe
Photoshop

166

a nation
is being
decayed
that
dont
abide
against
outsiders

بوروکراسی
BUREAUCRACY

right:
illustration Jam Packed
date 2007
media/techniques jelly and
plastic toys

Birthplace: Melbourne, Australia and Vietnam. *Education:* Swinburne National School of Design, Melbourne, Australia. *Inspiration:* Alejandro Jodorowsky, Arthur Russell, David Attenborough, Yoko Ono, Bernhard Willhelm, Rei Kawakubo, Hirokazu Koreeda, Michel Gondry, Harmony Korine, Yayoi Kusama, William Boroughs.

We both grew up in Melbourne and met while studying communication design. Now we work together out of a studio in the centre of the city. Ed studied visual arts and moved to multimedia before finally settling into graphic design. Tin has always been very interested in image making, whether it's illustration, collage, photography or anything visual. We are both definitely more interested in art, music, film, fashion, dance and architecture than the actual graphic design industry. Ideas can cross genres and when they do, the results are often more exciting.

Graphic design is an industry that is pretty much inseparable from the traditional art of typography. Labels often limit the way people think of things. Type can be explored in an infinite number of ways, you can't really say it is this or it is that – that's too limiting. We both tend to approach type as another form of image making, especially in the Crumpler ABC series, shown here and on the following pages.

It's very difficult to say where we take our inspiration from because it's not restricted to any single source. It comes from everywhere; from the culture that surrounds us, whether that is high culture – such as fine art – or today's pop culture. Everything that happens in the world or happens to us, or that we're exposed to, will inform and feed into our work. We are inspired by people and especially by our friends. If we had to identify some designers whose work we admire, it would be Sagmeister Inc. and Tibor Kalman. It takes a lot of guts to do some of the stuff that they did and we have such a lot of respect for that. We also really like Pushpin; Milton Glaser is such an amazing illustrator.

Our working methods are different for every job. We generally start by conceptualising the artwork – defining parameters whether it is medium or process – then experiment, produce and implement our ideas. We like to mix it all up. We don't like a single method of working and get easily bored (and are also easily distracted). We use anything we can get our hands on. We love using cardboard and paper, but we've pretty much used every material you can think of. At the moment we're really into industrial off-cuts and waste material.

Hopefully, in the future, people will think of type in more and more open and experimental ways. Our advice to anyone thinking of following a similar path should remember to always make it fun for themselves – that's the most important part of any design work.

TIN&ED

j a m p a c k e

b a d t o t h e b o n e

c r a z

u n i e s e

above left:
illustration Bad to the Bone
date 2007
media/techniques collage

above right:
illustration Crazy
date 2007
media/techniques mixed media

right:
illustration Universe
date 2007
media/techniques collage

172

a k e a b r e a k f o r i t

above left:
illustration Make a Break for It
date 2007
media/techniques sponge cake,
icing and liquorice

above right:
illustration Out of the Ordinary
date 2007
media/techniques electronic

left:
illustration Good As Gold
date 2007
media/techniques electronic

INDEX

CONTACTS

Tony Ariawan Kartiko
Email: tonyariawan@yahoo.com
Tel: +62 811 29 17 94
Web: www.area105.com

Alvin Chan
Email: alvin@alvinchan.nl
Web: alvinchan.nl

Alex Camacho
Email: mail@alexcamacho.es
Tel: +34 620 193 939
Web: www.alexcamacho.es

Hwan Uk Choe
Email: hanuku@gmail.com
Tel: +82 10 9505 6727
Web: www.hanuku.com

Emanuel Cohen
Email: emanuelcohen@gmail.com
Tel: 1 (514) 781-9121
Web: www.behance.net/
emanuelcohen

Yair Cohen
Email: downstairsgroup
@gmail.com
Tel: 972+9+8663603 or
972+50+2508212
Web: yaircohen.blogspot.com

Christopher Çolak
Email: cc@chriak.com
Tel: +90532 607 4885
Web: www.chriak.com

Michael Doret
Email: Michael@MichaelDoret.com
Tel: 323-467-1900
Web: MichaelDoret.com

Béla Frank
Email: frank.bela.78@gmail.com
Tel: +36 70 417 82 18
Web: www.fabergraph.hu/

Jaume Osman Granda
Email: osmangranda@osman
granda.com
Tel: 647139011
Web: www.osmangranda.com

Jesse Hora
Email: jesse@jessehora.com
Tel: 773-317-4672
Web: www.jessehora.com

Luca Ionescu
Email: luca@likemindedstudio.com
Tel: +61 414 417 635
Web: www.likemindedstudio.com

Iskra Johnson
Email: Iskra@iskradesign.com
Tel: 206-367-2643
Web: www.iskradesign.com

Sarah King
Email: sarah@eveningtweed.com
Tel: 07814916587
Web: www.sarahaking.com

Karoly Kiralyfalvi
Email: hello@extraverage.net
Tel: 0036-30-280-2833
Web: www.extraverage.net

Luke Lucas
Email: luke.lucas@lifelounge.com
Tel: +61 411 811 080
Web: www.lukelucas.com or
www.lifelounge.com

Mihail Mihaylov
Email: mikaso@abv.bg
Tel: +359 887 26 45 54
Web: www.typographicposters
.com/mihail-mihaylov

Oliver Munday
Email: oliver.munday@gmail.com
Tel: 202.294.4534
Web: www.olivermunday.com

NeoDG
Email: info@neodg.com.ar
Tel: (005411) 49548102
Web: www.neodg.com.ar

Amitis Pahlevan
Email: sayhello@amitis-
pahlevan.com
Tel: 949.677.3757
Web: www.amitis-pahlevan.com

Kum-Jun Park
Email: kj@601bisang.com
Tel: +82 2 3322 601
Web: www.601bisang.com

Petar Pavlov
Email: contact@petarpavlov.com
Tel: +389 71 791 650
Web: www.petarpavlov.com

Richard Perez
Email: info@skinnyships.com
Tel: 1.562.631.5614
Web: skinnyships.com

Jeremy Ryan Pettis
Email: mrpettis@gmail.com
Tel: 414.243.9447
Web: www.jeremypettis.com

Andrei Robu
Email: andrei.robu@gmail.com
Tel: 0040 744 304 886
Web: www.andreirobu.com or
www.acmeindustries.ro

Svetlana Sebyakina
Email: sebyakina@yahoo.com
Tel: +7 926 269 54 62
Web: sebyakina.ru/

Heesun Cristina Seo
Email: def0021@gmail.com
Tel: +82-10-9972-8711
Web: hxx.kr

Shahab Siavash
Email: shs@shahabsiavash.com
Tel: +989119312302
Web: www.shahabsiavash.com

Sicksystems
Email: info@sicksystems.ru
Tel: +7 926 5660721
Web: www.sicksystems.ru

Allan Sommerville
Email: allansom@mac.com
Web: www.allansommerville.com

Fiodor Sumkin
Email: opera78@gmail.com
Tel: +33 6 98 45 24 89
Web: www.opera78.com

Tin&Ed
Email: design@tinanded.com.au
Tel: +613 671 3777
Web: tinanded.com.au

Vasava
Email: vasava@vasava.es
Tel: (+34) 935396430
Web: www.vasava.es

Laura Varsky
Email: lv@lauravarsky.com.ar
Tel: +54 11 4658 5015
Web: www.lauravarsky.com.ar

**Craig Ward / Words Are
Pictures**
Email: info@wordsare
pictures.co.uk
Tel: +44 (0) 7841 518 850
Web: www.wordsare
pictures.co.uk

Nate Williams
Email: art@magnetreps.com
Tel: (866) 390-5656
Web: www.magnetreps.com or
www.n8w.com

Jonathon Yule
Email: jonathon@invdr.com
Tel: 647-894-4177
Web: www.invdr.com